Drawing **Portraits** *In All Mediums*

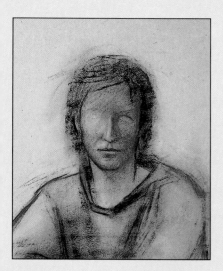 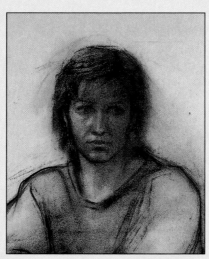 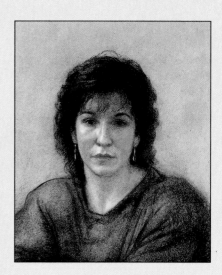

JOSE M. PARRAMON

Please return my book

OF RODENTS AND PERSONS

Watson-Guptill Publications/New York

Copyright © 1989 by Parramón Ediciones, S.A.

First published in 1991 in the United States by Watson-Guptill
Publications, a division of BPI Communications, Inc.,
1515 Broadway, New York, New York 10036.

Library of Congress Cataloging-in-Publication Data

Parramón, José María.
 [Dibujando retratos. English]
 Drawing portraits in all mediums / José M. Parramón.
 p. cm.—(Watson-Guptill painting library)
 Translation of: Dibujando retratos.
 ISBN: 0-8230-1457-6
 1. Portrait drawing—Technique. I. Title. II. Series.
 NC773.P3813 1991
 743'.42—dc20 91-10274
 CIP

Manufactured in Spain
Legal Deposit: B-11.080-91

1 2 3 4 5 6 7 8 9 / 95 94 93 92 91

Drawing
Portraits *In All Mediums*

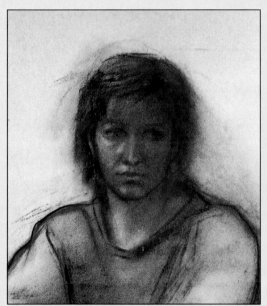
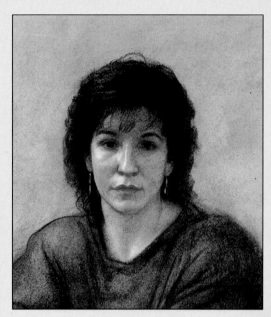

The Watson-Guptill Painting Library is a series of books that set out to teach how to draw and paint by showing what various professional artists do, and how they do it. Each volume in the series concentrates on a different medium—such as oil painting, water-color, acrylic, pastel, or colored pencils—and one particular subject: landscape, seascape, still life, the human figure, and portraits, among others. Each book also has an introductory section offering some theoretical background related to the subject. The subject of this present book, for example, is drawing portraits, and in the introductory section we will look at poses, composition, and lighting as well as creating a likeness. Each volume also describes the techniques used when painting or drawing in the medium the book is concerned with.

But what is really extraordinary about the Watson-Guptill Painting Library is that all the aspects each book deals with—such as choice of subject, composition, interpretation, color harmony, light and shadow, value, and color temperature—as well as all the techniques, the tricks and secrets of the trade, the experience and skill of various professional artists—all this is explained and illustrated line by line, stroke by stroke, step by step, accompanied by photographs of the artist at work.

I am proud of the teamwork that has produced this series and which I personally supervised. I honestly believe that this series of books can teach you how to paint and draw.

José M. Parramón
Watson-Guptill Painting Library

The art of drawing a good portrait

To draw or paint a good portrait, the first requirement is a mastery of drawing in general, and of the construction of the human head in particular.

You have to know the human head as a whole, and the proportions and forms of its parts: the eyes, nose, mouth, ears, chin, and hair.

What, then, are the features of a good portrait? The first feature is obvious:

The portrait must be an exact likeness of the subject.

Of course, a portrait is the likeness of someone, and that someone must be recognizable in the portrait. Nevertheless, the term ''exact likeness'' needs further explanation. You have to take into account such characteristic features of the subject as the shape of the nose, as well as characteristic gestures and personality—whether your model is shy or an extrovert, for example.

A good portrait must also be a work of art.

That is to say, it must be, above all else, a good drawing or a good painting. Mere likeness is not enough. When we admire a portrait by a famous artist such as Velázquez's *Portrait of Pope Innocent X*, *Giaconda* by Leonardo (1452-1519), or a self-portrait by Titian (1488-1576), we cannot tell how good a likeness it is of the subject, but that does not matter to us very much; what matters is the intrinsic value of the picture.

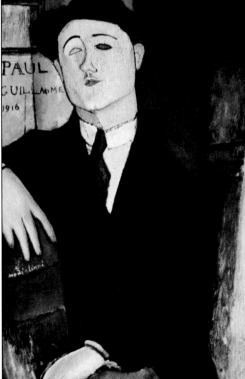

Fig. 1. To master the art of the portrait, it is essential to study the human head through sketches. All the great portrait artists are also masters of drawing and painting the human figure, head, and face.

Fig. 2. Diego Velázquez (1599-1660), *Portrait of Pope Innocent X*. Doria Art Gallery, Rome. This is considered one of Velázquez's finest portraits, and not because of its likeness to Pope Innocent X, but because of its structure, color, and contrast—in fact, because it is a work of art.

Fig. 3. Amadeo Modigliani (1884-1920), *Portrait of Paul Guillaume*. Civica Modern Art Gallery, Milan. This portrait was painted in 1916. Up to then, Modigliani had been a sculptor as well as a painter. In his portraits, with their characteristic personal, free style, we can appreciate the point of view of the sculptor.

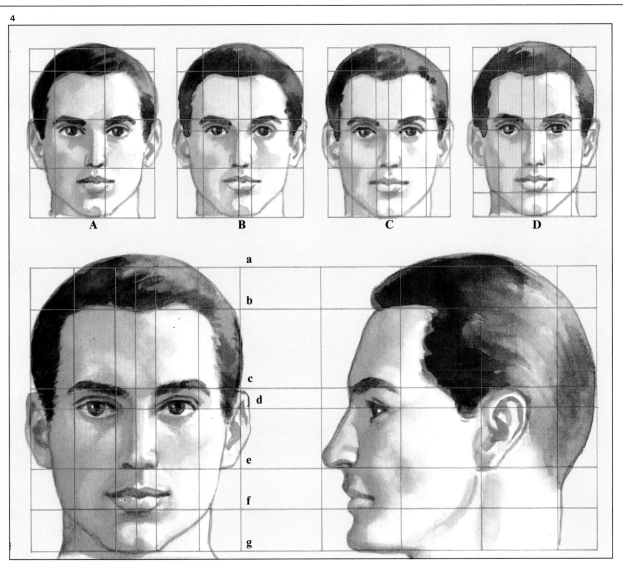

4

A B C D

a
b
c
d
e
f
g

Shown above are two male human heads, one seen from the front, the other in profile, drawn according to the canon of the ideal dimensions and proportions for the human head. Note that the head seen from the front takes a rectangular form measuring three and a half units high by two and a half units wide, taking the height of the forehead as one unit or basic module.

In figures A, B, C, and D above, you can follow the step-by-step process of drawing the canon for the human head seen from the front. Note that the height of the rectangle is made up of 3½ units (figure A), and the width of 2½ (figure B). Finally, note the positions of the main features of the face. The basic lines are labeled a, b, c, d, e, f, and g.

Fig. 4. To increase one's mastery of the portrait, it is important to study the human head and practice drawing it, with the help of the canon shown above.

Physical likeness

As we have already pointed out, physical likeness does not depend simply on photographic precision or on exact proportional measurements. There are other factors at least as important as this type of precision:

a) The mathematical construction of the head.
b) The exaggeration of characteristic features.
c) The model's gesture and pose.
d) The model's characteristic features.

These first two factors correspond to purely physical aspects of the model. The last two correspond to the personality and character. First we will look at how to get a good physical likeness, considering one aspect at a time ... but, don't you believe it —you do them all at once! The thing is, to analyze the various factors first, and then, when you actually get down to work, you realize that they are all parts of a whole.

Ingres, a painter and draftsman who was a contemporary and rival of Eugène Delacroix, gave his students such excellent advice that we can still follow it today— and we will follow it—to approach the problem of likeness:

"Seek perfection from the start. Build, seek, unite, compare the longer distances, the great strokes of the brush, harmonize." That is to say, calculate the distances and make them harmonious; get the position and proportion of the parts of the head right. Put more simply, draw exactly what you see in front of you.

"Everything we see has a caricature that we must capture. To discover that caricature, a painter must be a physiognomist."

Look closely at your model. You are not a camera or a set of compasses. We all possess other talents: the ability to distinguish one thing from another, and to remember people for particular things about them. We must make use of our intelligence and our imagination so that they can help us to note our model's special qualities and distinctive features. We must exaggerate. What are his or her eyes like? Are they big or small, close together, half-closed? Is the face round, long, square, or what? In short, look for the caricature, which is a brief synthesis of the features that makes a person what he or she is. And the artist must slightly emphasize these distinguishing features, the ones that make the model different from anyone else. He or she must consciously bring them out, in order to capture the physical image that makes each of us unique and immediately recognizable.

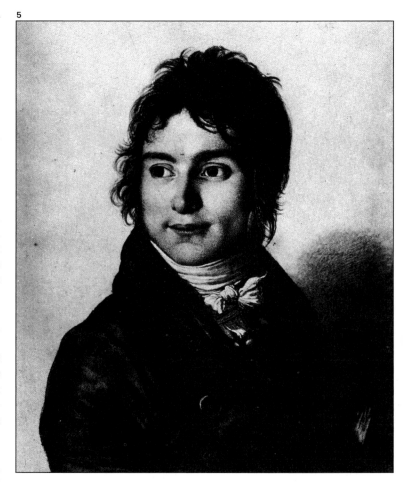

Fig. 5. Jean-Auguste-Dominique Ingres (1780-1867), *Study of a Head.* Orleans Museum, France. This study of a human head contains the basic ingredients for achieving a good likeness: construction, characteristic features, and a good pose.

Ingres's advice to his students

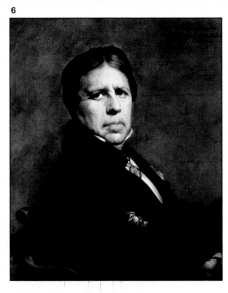

6

Fig. 6. Jean-Auguste-Dominique Ingres, *Self-portrait*. Koninklijk Museum voor Kunsten, Antwerp.

A master of the portrait

At work in his studio, Jean-Auguste-Dominique Ingres taught his students how to paint or draw a portrait so that it not only resembled the model, but became a work of art. Ingres's advice was collected by a descendant of one of his pupils, and it forms a master class on the art of the portrait. Here are the most relevant of his teachings:

There is a caricature in everything we see, and we must capture it.

The painter must be a physiognomist, and must seek out the caricature.

The good artist must penetrate the mind of the model.

Grasp the uniqueness of your model.

Note the pose of the head and body; bring out the character of the person you want to paint. The body should not follow the movement of the head.

Examine the model in depth before you begin.

No two people are alike; give each every bit of his individuality, even in the smallest details.

Sketching is the art of grasping the character, the dominant traits, and personality of the subject.

Study and observe the characteristic poses of each age group.

In movement, one profile is always more significant than another.

The artist must be ever watchful, ever mindful of detail, bringing everything together at the same time and harmonizing right up to the last moment.

Draw the eyes as you go.

Work like mad at the darker parts, but develop them!

It is not the white that first meets the eye; it is the medium shades and the deep shadows.

Details tell a great deal, so it is necessary to harness them.

Note the limits of the shadows, the medium shades, and the highlights.

Avoid too many highlights—they can spoil the effect.

Seek perfection from the start. Build, seek, unite, compare the longer distances, the great strokes of the brush, harmonize.

Psychological likeness

So we move on in our search for "perfect likeness," still bearing in mind that magnificent artist Ingres and his advice.

"Study the pose of the head and the body; capture the character of the person you are going to paint. First note the natural physiognomy of your model; position him accordingly, let him express himself naturally."

Once again, Ingres finds just the right words to tell us where to focus our attention. We all have a "pose"; we all have a characteristic gesture or number of gestures, a way of sitting, of standing, of looking—things that characterize us in the same way as the color of our hair. Sometimes this is extraordinarily evident. Take Ingres's portrait of Napoleon with his left hand inside his jacket, or Rembrandt's portrait of his son studying: the hand holding the pencil; the head resting slightly on the same hand; the lost, pensive expression.

"The good artist must penetrate the mind of the model."

This is the last piece of advice on likeness. What sort of person is the model? What expression is there on his or her face? Is it sad, or reserved, or happy and confident, or shy, or shameless?

Observing your model's face, expression, and characteristic look is as important as getting to know the model, talking with him or her, finding out the best way you can portray that person's face and character. For example, you must determine the most suitable lighting, the ideal pose, and, even more important, the best composition for your picture.

To get the best results, combining all these factors—construction of the head, characteristic features and gesture, and character—and furthermore, putting it all into the work so that it is not only a portrait, but also a work of art, Ingres gives us some advice that seems particularly valid:

"Examine the model in depth before you begin."

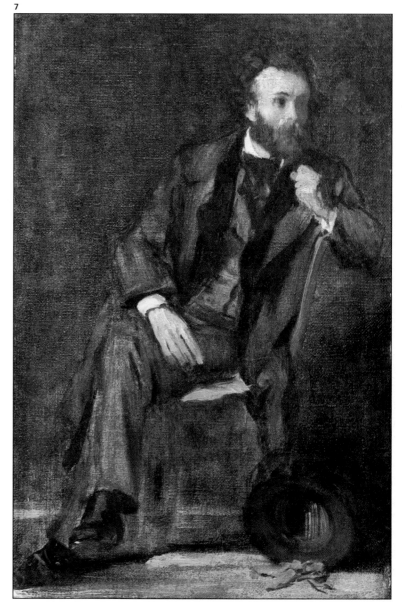

Obviously, Ingres is not talking about chatting, much less prying. He means we must try to get to know the model. This, of course, is done by talking to the model, but not only by talking. The best thing is to do some sketches, lots of sketches, so that they represent many questions and answers. Each one tell us whether we are right about something we feel we see in our model.

Fig. 7. Edgar Degas (1834-1917), *Portrait of Gustave Moreau.* Gustave Moreau Museum, Paris. This is an original and characteristic pose illustrating Ingres's advice. The painter was, in fact, an admirer of Ingres.

8

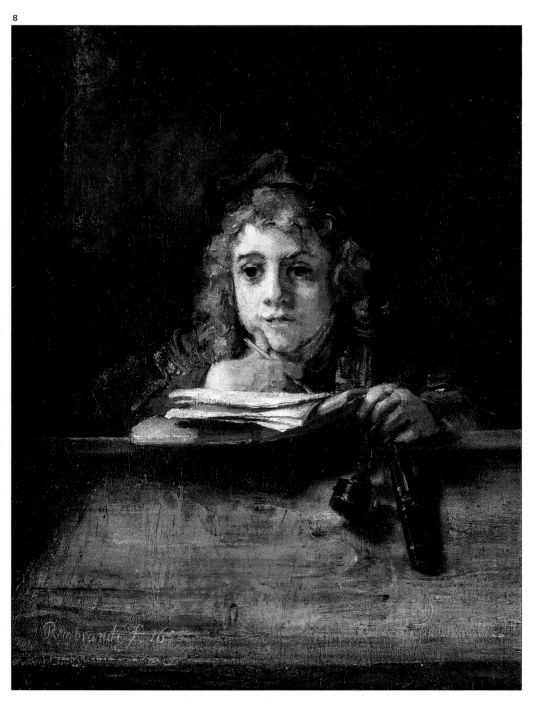

Fig. 8. Rembrandt (1606-
1669), *Tito Studying*.
Doymans-Van Beuningen
Museum, Rotterdam. With
this portrait of his son,
Rembrandt offers us a fine
example of physiognomy,
character, and likeness.

The portrait as a work of art

Fig. 9. John Singer Sargent (1856-1925), *The Hon. Mrs. Gilbert Leigh.* Private collection. In this charcoal portrait, Sargent has achieved two of the portrait artist's primary goals: to create a convincing likeness and to infuse the work with artistic quality.

Fig. 10. When deciding on the model's pose, it is important to remember that the model's eyes should be level with those of the artist.

Fig. 11. A book is often the solution for those who do not know what to do with their hands.

Leaving aside likeness, what do we have to do so that our drawing, our portrait, has artistic value in its own right? We will now look at some factors that we will expand on later.

a) The model's pose must be comfortable. The facial expression and gesture should be both natural and expressive.

b) The lighting should be planned carefully to enhance the desired effect.

c) The composition must be well thought out. Should the portrait show the head alone, or the upper half of the body? Preliminary sketches are important to find the best arrangement.

d) The format and size of paper, as well as drawing materials, should be chosen with care to create the intended style of the portrait.

The model's eyes must be level with your own.

True, this need not be a hard-and-fast rule; the position can be changed if a more expressionist effect is being deliberately sought, for example. Generally, though, keeping the model's eyes level with yours is a good idea.

We have to make the model comfortable, help him or her feel at home and get into a normal position. So here is the second rule:

The model must feel comfortable.

Note also the clothes and hair of your model. They should be natural too, the way the model usually dresses. Do not make the model look as if he or she has just come out of the hairdresser's, or is wearing awkward,

9

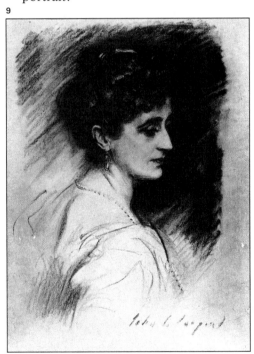

Studying the pose

To start with, we can say that the most normal position is for the model to pose sitting down, whether the portrait is of the head only or is a half-lenght portrait. At any rate, remember one important rule: The model's head should be at the same height as the artist's.

10

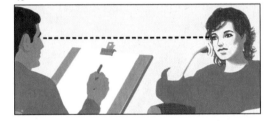

11

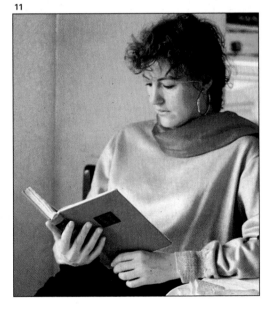

brand-new clothes. Normal, everyday clothing, a little creased and worn naturally, is a good starting point for our portrait. On the other hand, you need not copy everything faithfully. Tell the truth, but twist it a little if you feel it necessary; improve it a little. Iron out a few wrinkles, bring the hairline forward, make any change your imagination tells you is right.

And another thing: Look at your model's hands, and make sure they are positioned naturally. If necessary, give the model something to do with them: a book, a flower, a jacket, or whatever—but only if necessary.

Finally we will now decide on the model's pose. Of course, it is important to change the model's "natural" position as little as possible, but you must get the most you can out of it, sometimes by exaggerating it, other times by softening its effect. Ingres gave us more good advice on this:

"The body should not follow the movement of the head."

He meant that the head and the body should face in different directions. If we follow this advice, the pose will be more interesting.

Art knows no absolute rules, however, and this is a piece of advice, not a rule. Modigliani, for example, painted many portraits with the model's head and body looking straight to the front, though it is also true that he painted many others where the pose of the head and body form an enormously graceful movement.

It is a very good idea to look at and study the works of great painters. They all have something to teach us.

Fig. 12. Jean-Auguste-Dominique Ingres, *Portrait of Paganini*. Louvre, Paris. In this portrait Ingres followed his own advice to his students: "The body should not follow the movement of the head."

Fig. 13. Amadeo Modigliani, *Woman Dressed in Black*. Private foundation, Art and History Museum, Geneva. Modigliani was not the only artist to disregard Ingres's rules, and here is an example of one of his portraits where both the body and the head are facing straight ahead.

12

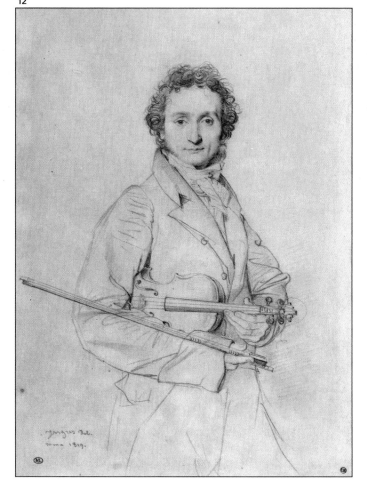

13

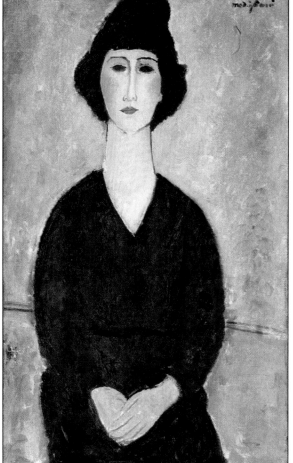

Composition

To study the model, the pose, the lighting, and your position in relation to the model, there is nothing better than taking a pad or some sheets of paper, not too big, and making some sketches. Keep changing your model's pose, and draw all the poses he or she takes. Move around and draw the same pose from different angles. Also try keeping your position and the model's the same, but changing the framework of your paper.

When we experiment with positions for the model, viewing the model from different angles, and different positions on our paper, what we are doing is solving a problem of composition. That is to say, we are determining the proportions between the mass of the model's shape and the space on the paper, the amount of space that the model takes up on the paper, and the relationship between the whites and grays of the drawing of the model and the paper on which we will draw it.

This is the main problem of doing a good drawing and, at the same time, a work of art. Remember, most of the great painters also make this type of sketch.

If you are going to do a portrait of a head alone, you must find the right place on the paper for the head. Here is another rule: Draw the head a little above the geometric (real) center of the paper.

Another piece of advice from Ingres: "Leave more space in front of the face than behind."

If you are going to do a half-length portrait, make plenty of preliminary sketches. Try the model's arms in different positions, and the head at an angle or leaning back in the chair.

14

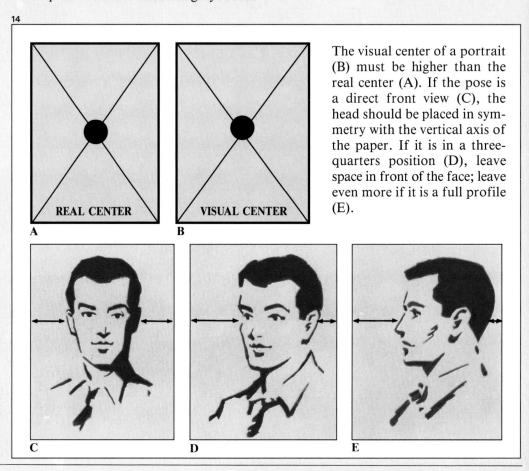

A B

REAL CENTER VISUAL CENTER

C D E

The visual center of a portrait (B) must be higher than the real center (A). If the pose is a direct front view (C), the head should be placed in symmetry with the vertical axis of the paper. If it is in a three-quarters position (D), leave space in front of the face; leave even more if it is a full profile (E).

Fig. 14. Since the visual center (B) of a space is slightly higher than the real or geometric center (A), the head of the portrait should be placed a little above center. When the head is drawn from a frontal position, it is normally placed right in the center (C), but when the pose is either three-quarters or profile, there should be slightly more space in front of the face than behind it (D and E).

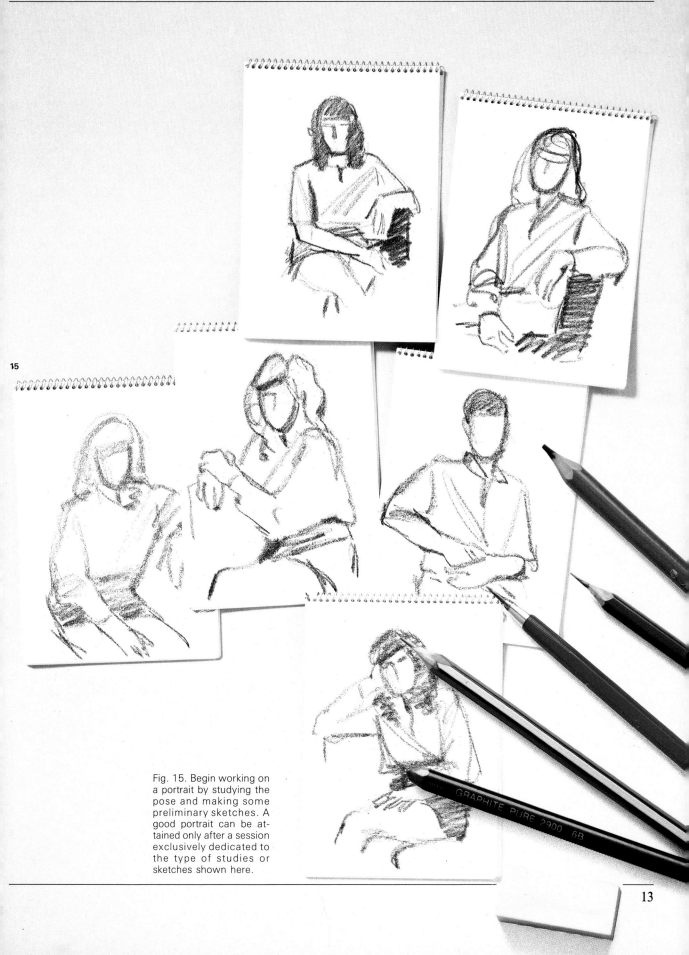

Fig. 15. Begin working on a portrait by studying the pose and making some preliminary sketches. A good portrait can be attained only after a session exclusively dedicated to the type of studies or sketches shown here.

Lighting

Nearly all portrait artists prefer to work with artificial light. Why? For three good reasons:

First and foremost, because they are not bothered about color, just light and shade.

Secondly, because artificial lighting is directed and solid; therefore it focuses on and brings out features and dominant traits better than natural light would.

Thirdly, because it can be moved and varied to choose the best direction and shading. It also allows the artist to work at any time of the night or day.

The most favorable direction of the light is without doubt from one side —more nearly front-on than to the side— and just a little above the model, so that a little shadow of the nose is cast.

But this is not to say that it must always be like this. Each different model demands a particular type of lighting.

Size and format

The most common size of paper for, say, a half-length portrait depends on the country where you buy the paper. In the United States it would be $22 \times 30''$, or half of that, $22 \times 15''$. In Europe it is easier to get paper measuring 50×65 cm, so that half a sheet would measure about 50×35 cm. Having said that, for each portrait the best thing is to find the most suitable format, making it longer, more square, or more oblong as appropriate.

The definitive portrait

Now you are ready to put all you have learned so far into practice. Choose the best sketch, position the model's mass on the paper with an outline or loose areas of color, study the shadows and values ... and get down to work.

Regarding paper and materials, the following pages show you various examples, such as charcoal, wax crayons, lead pencil, sanguine or chalk, and Koh-i-noor leads.

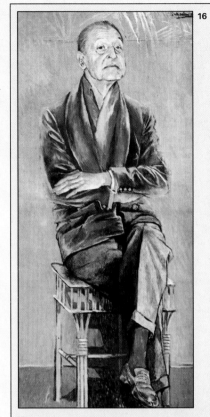

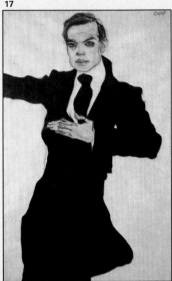

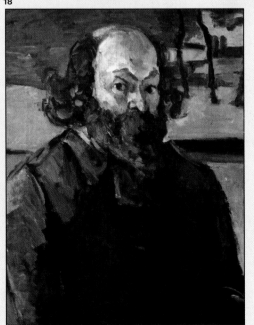

Figs. 16 to 18. There are standard sizes of paper for portraits, but you can, of course, vary the dimensions of the paper you choose to work with, selecting different sizes, as in the three portraits shown here. Graham Sutherland (1903-1980), *W. Somerset Maugham*. Tate Gallery, London (figure 16). Egon Schiele (1890-1918), *Portrait of Max Oppenheimer*. Graphische Sammlung. Albertina, Vienna (figure 17). Paul Cézanne (1839-1906). *Self-portrait*. Musée d'Orsay, Paris (figure 18).

19

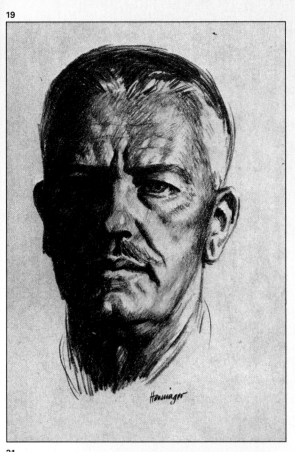

20

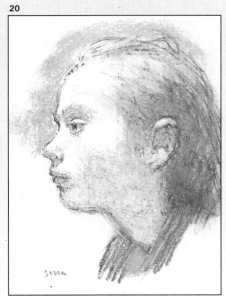

Figs. 19 to 22. In figure 22, we have an example of artificial lighting, the light falling frontally, from a little to one side and at an angle above the model determined by the small shadow cast by the nose. This is the most common lighting arrangement for a portrait, but not the only one, as we can see from the different examples on this page. They are (figure 19) J.M. Henninger, *Self-portrait*. Collection of Mr. and Mrs. Henninger, Santa Monica, California; (figure 20) Francesc Serra, *Pastel*. Private collection; and (figure 21) Isidro Nonell (1873-1911), *Asunción*. Modern Art Museum, Barcelona.

21

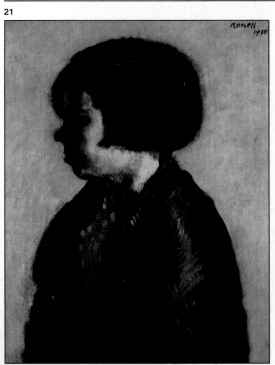

22

A child's portrait

Esther Serra is a young painter, a graduate in painting and sculpture. At present, she teaches drawing and painting at various centers. She has had several exhibitions of her work and is also an expert in the field of illustration.

Esther Serra is our guest artist for the portrait of a child in charcoal. The child, Héctor, is here with us. He is eight years old, with dark hair and big black eyes.

Serra starts off by telling us that a portrait of a child is, if anything, more difficult to execute than that of an adult. This is because children find it difficult to hold still, because there is a danger of portraying the child as older than he is, and because of the smoothness of the face.

But she means to defeat these obstacles. She gets the child to sit on a sofa, and starts trying different poses. She talks to the boy all the time, even though Héctor does not quite understand that he just has to pose naturally for the artist and the photographer.

Esther Serra has her studio in an old apartment. It takes up a large room that looks onto the street and the floor is carpeted to keep outside noise down. The artist has chosen soft artificial lighting for this portrait, and has placed it facing Héctor. This way is the best for drawing a child, because there are few contrasts on Héctor's face, and for the portrait of a child we do not want many hard features.

The materials

Serra is going to draw a number of sketches before starting the final portrait. She will use the same materials for both the preliminary sketches and the final portrait, and even the same paper, a white Ingres, which she has cut into smaller sheets for the sketching. It is easy to guess the materials she plans to use even before she says to us, "I am going to use charcoal basically, plus a black pastel, a charcoal pencil, and maybe a hard lead charcoal. I'll also use a cloth and, above all, my fingers."

23

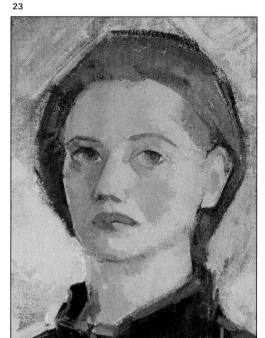

Fig. 23. Self-portrait in oil by Esther Serra, the young painter who is going to draw a portrait in charcoal for us step by step.

24

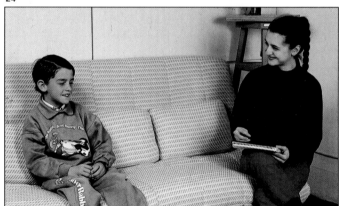

25

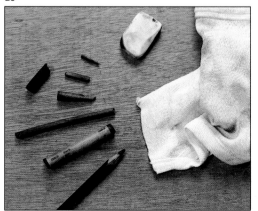

Fig. 24. During this first contact, Serra sits close to the child, studying him closely. While she draws, she talks to him, relaxing him.

Fig. 25. Esther Serra's materials: a cotton cloth, a normal rubber eraser, pieces of charcoal stick of all sizes, a Faber Castell charcoal pencil, and Rembrandt black soft pastel.

26

27

28

Figs. 26 to 28. In these reproductions of some of Serra's work, we can see her mastery of different media: wax crayons (figure 26), watercolor (figure 27), and sepia ink (figure 28). But above all, we can see in her work the search for balance between two tendencies, definition of form and delicacy of expression.

Preliminary sketches: composition and study of the face

Now everyone is busy—the child, whom Serra puts into different positions; the photographer, who takes shot after shot, since Serra may need the photos later to finish the portrait after Héctor has left; and of course, the artist, who makes sketches of Héctor in different positions, some of which are reproduced below. She is seeking the right pose and composition studying the structure of the head and the expression of the face. She also tries slight changes in the lighting, while keeping it soft and frontal, with a small shadow under the nose and a lighter shadow on one side of the head.

Héctor sits still... then moves... then suddenly flops down on the sofa in a more natural position. He bends his legs a little, beginning to get used to these people scrutinizing him, and even smiles. The artist is careful to position him in an attractive pose. She gets him to move his head, to a frontal position when the body is turned, to a three-quarters position when the body is almost in profile. "The body should not follow the movement of the head," said Ingres, and Serra seems to remember this instinctively.

29
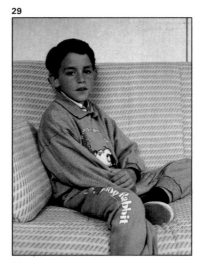

30
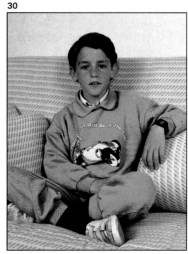

31
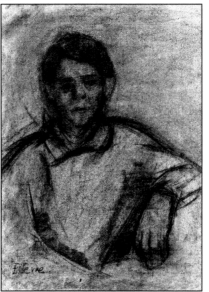

Figs. 29 to 34. These photos of various poses Serra tried with the child, and the sample sketches she made, show the two types of preliminary study you should do before starting a definitive portrait. These are sketches of the overall composition, as in figures 33 and 34, and studies of the head, as in figure 32. Quick sketches like these help you compose and get to know the model.

32
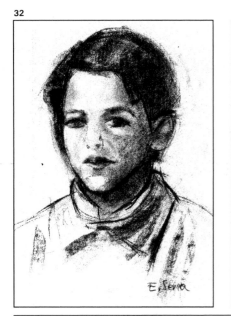

33
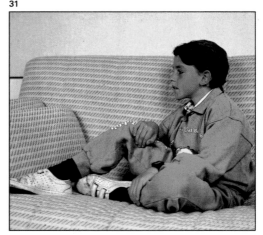

34
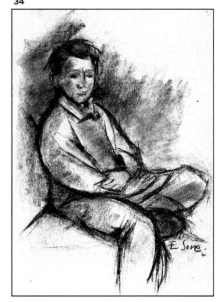

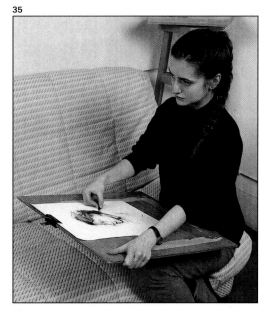

35

She makes light strokes with the charcoal pencil, going over the same spot many times as if seeking the right line, firm about the direction she wants the lines to take. At the same time, she is making decisions about heavier strokes and the key areas and proportions, drawing everything at once, the charcoal gliding over the whole sheet of paper.

Line and shading blend together in her sketches, the shading defining form as she adds it. Often she starts to outline the shape of the face with a thick, transparent line drawn with her finger, which she has previously covered with black pigment. In this way, the lines and the contrasts are not abrupt, but smooth, as the face of a child demands.

Note that even while she is studying the head itself Serra does not waste time on the details of those features that are most familiar to us (the eyes, the nose, the mouth). She concentrates instead on outline and shade, as if those features, so well-known, but often so little observed, will appear in the drawing by themselves.

Figs. 35 to 39. In this step-by-step illustration of Serra sketching the profile, note the use of the charcoal pencil to draw outlines (figure 38), and how to dirty your finger with black pastel before drawing with it, achieving soft shadows (figures 37 and 39). Observe the richness of the simple sketch, which is already acquiring volume. Note also how crucial it is to define the position of the eye in relation to the ear and nose.

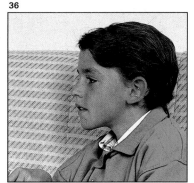

36

37

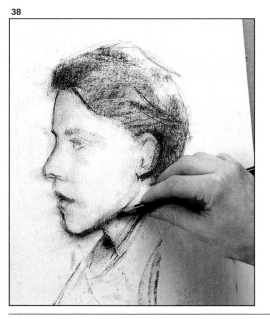

38

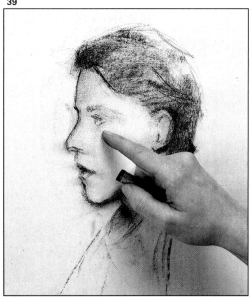

39

Step one: space

The artist starts the definitive drawing on a piece of white Ingres paper 26 × 20″ (65 × 50 cm). She places this on the easel, at about 5 feet (1½ meters) from the model. She works from life, using the same pose as for her last sketch, as you can see (figure 34).

Serra uses her finger, covered in black pigment, to put in shade with faint, broad lines, looking for the right position on the paper. The position of the head will finally be between frontal and three-quarters, so she places it to the left of center. With the charcoal pencil and her finger, she puts in shadow so lightly that it seems more to help her remember where it should go than to serve as real shadow. At the same time, she draws in firm, angular lines with a finer charcoal pencil.

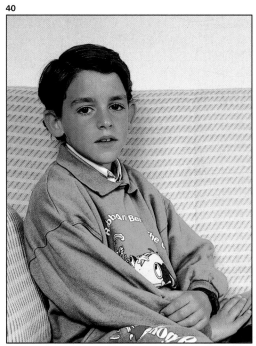

40

Fig. 40. This pose is the one that most interests the artist, and she decides to draw a portrait of the face.

Figs. 41 to 44. Note how Serra begins the portrait with a broad, transparent outline on the paper made with a dirtied finger (figure 41). She dirties more fingers (figure 43) to enable her to draw in broad lines side by side, as in the hair (figure 42), then cleans her fingers again (figure 44).

Fig. 45. By going over the same place repeatedly with the charcoal, she has defined the outline of the face, the shape of the chin, and the suggestion of the neck of the jersey.

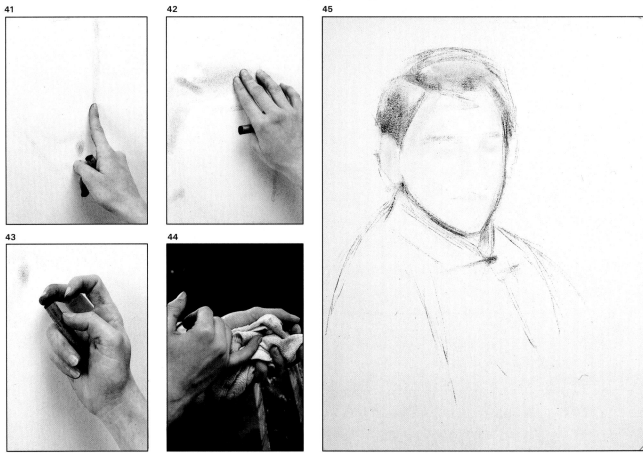

41

42

43

44

45

Step two: defining the features

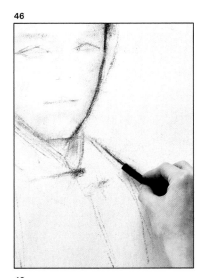

46

47

Our artist now begins to add definition to the features of the face—the eyes, the line of the mouth, the ears—that will give likeness to the portrait. She does this with the charcoal pencil, producing fine, delicate lines that seem to explore rather than to define. She holds the charcoal flat against the paper, because, as she says, "You can control your strokes better, and the lines are firm and decided, not soft and shaky. With the charcoal flat against the paper, I get fine, rounded lines. I get wide strokes or shade by holding the charcoal sideways."

She gets variation of tone from black to white by rubbing with the charcoal pencil from a very dark line on the paper, so that the pencil spreads pigment across the paper, more thinly and lightly toward the center of the face.

Note, in the results of this second step, the way volume is merely suggested. The drawing has a light, airy feel that makes you want to continue working on it.

49

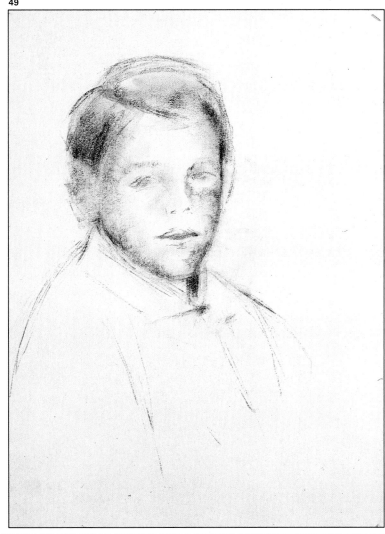

Figs. 46 to 49. These photos show different strokes with the charcoal pencil: holding it flat to define the outline (figure 46); again holding it flat, but this time perpendicular to its movement, to put in defining shade in the hair (figure 47); and using the point for the lines defining the shape of the eyes (figure 48). All these kinds of lines are evident in figure 49.

48

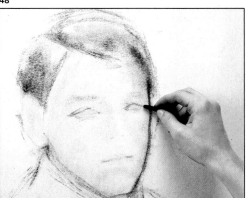

Step three: shading

Now Serra gets on with shading the picture, using both visible strokes and blending. Soon she has started to bring out the contrasts between the shaded and the clear areas of the picture, to the extent of making it perhaps a little unreal, lacking in harmony, meaning that she has not yet decided the volume. But this over-reinforcement will be useful later as, with the charcoal pencil (the perfect instrument for this job) she refines gradations of value by adding, connecting, rubbing out, and creating transparency.

Note, also, the richness Serra brings out, in the hair, for example—a graphic richness, a richness of reinforcement, of shade, of straight strokes, and subtle grays.

She constructs well, perhaps because besides painting and drawing she also does sculpture. We think of other painters who were also sculptors, such as Pablo Picasso (1881-1973) and Henri Matisse (1869-1954), who both drew magnificently; or the Frenchman Auguste Rodin (1840-1917) or

Figs. 50 to 52. Serra strengthens the lines of the face, ears, and jersey. With the cotton cloth wrapped around one finger she softens shadows, always at the same time drawing more and more.

52

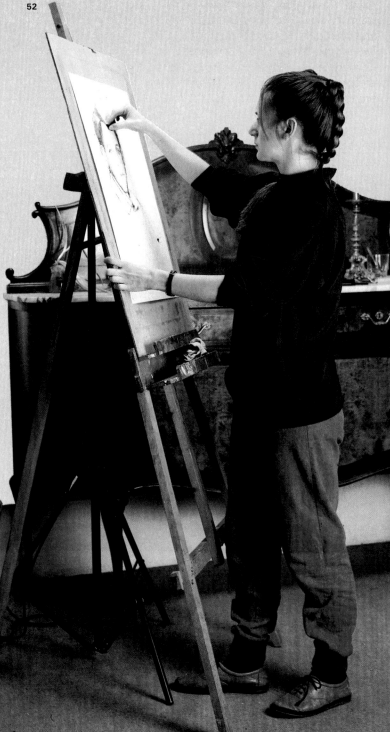

50

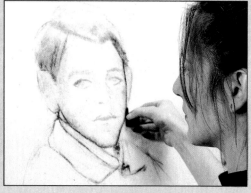

51

the Englishman Henry Moore (1898-1986), who drew with great precision without neglecting the expressive aspect of the art of drawing.

The portrait is starting to take form; note the resolution of the hair, which now has a defined form of its own.

Serra relates each part to the whole; one ear is related to the other ear, to the nose, and to the space between the head and the jersey where she will add the neck. Her lines now are defined and help build up the whole picture. She moves her pencil across the paper deftly, decisively. Lines join or end, creating changing rhythms, like the place where the collar of the jersey meets the line of the shoulder and the left arm.

The artist uses the charcoal to put in more and more shade while also bringing out form; she sees, for instance, that the left ear is out of proportion, and corrects this, then rubs hard to get the hair to the correct length.

Figs. 53 and 54. With the tip of the charcoal pencil, the artist can make bold lines (figure 53) or suggest shade by drawing fine, tiny lines, defining the nostrils.

Fig. 55. Observe the lines making up the outline, which is not just a silhouette, but the result of tense, rich lines of varying thicknesses, searching for form. Serra has also used the graphic effect of tiny lines in other parts of the drawing, though never in the same way twice.

53

54

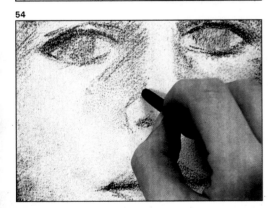

55

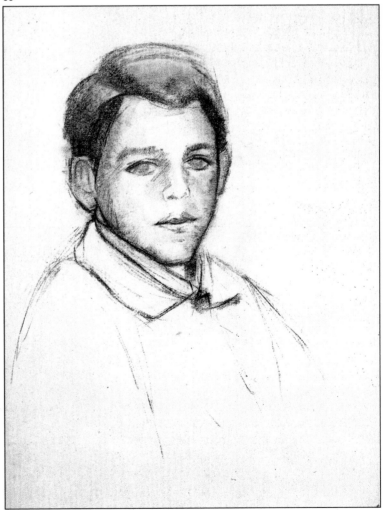

Step four: flesh and form

Serra is as relaxed, hard-working, and concentrated as when she started the portrait. She now starts work on two basic aspects that remain to be resolved. This, even though her picture seems to be at such a ripe stage that one might think the rest would appear by itself out of what our artist has already expressed on the paper. This is a prime example of artistic know-how: Serra has spent two hours ceaselessly going over the whole sheet of paper, concentrating on the principal lines until she really "feels" them, and completing what we could call the task of giving depth.

The first of the two basic aspects that remain is rendering the texture of the model's skin. Through intelligent use of the black charcoal pencil, gradations of shade appear and the flesh becomes smoother.

The second is the definition of forms. She works on the eyes decisively, bringing out the black of the child's thick lashes, which surround and cast shadow onto the eyes. Now she draws the mouth, and remembers that, as Picasso said, observing is an important act. It is crucial not just to observe the mouth as a mouth, but to observe the contrasts between light and shade, and the dark spaces that define the mouth as much as the shape of the lips themselves. (Sometimes it is just as useful to observe the space between two objects as it is to observe the form of those objects.) The drawing now has its definition. Serra has captured the shape of the eyes, the chin, and the nose.

A brief technical digression: The artist has been using the charcoal pencil to its best effect, not overdoing it, but adding little by little, rubbing lightly so as not to remove the bottom layer. She has hardly used the eraser at all, and the cloth just enough to blend different areas together or to give the idea of depth. She herself tells me that she normally uses few materials. She does not use large amounts of pigment, but neither does she take much off, and hardly rubs anything out at all.

Héctor, the model, is starting to get tired, but that is all right now. Serra will carry on tomorrow from the photos taken at the beginning of the session.

56

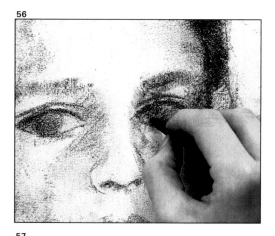

57

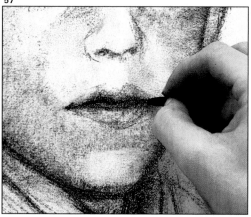

58

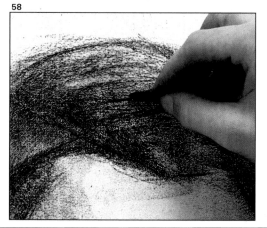

Fig. 56. She shades the white of the eye, which, as you know, is never totally white, but changes according to light and shade, just like anything with volume.

Fig. 57. The child's mouth, a characterizing feature in the model, is taking shape. With a tiny piece of charcoal, Serra has drawn a broad stroke separating the upper lip from the inside of the mouth.

Fig. 58. The hair takes on volume and graphic density. Note the wide variety of techniques she uses to resolve the hair, ranging from deliberate blurring to fine lines to broad strokes.

Have a good look at the results so far. Try to guess what is still missing, bearing in mind that it may not be the same for you as for Serra. She has caught the expression, the form, the likeness, the steady but mild look of the eyes, the tone, and ... What else must she add to the portrait?

59

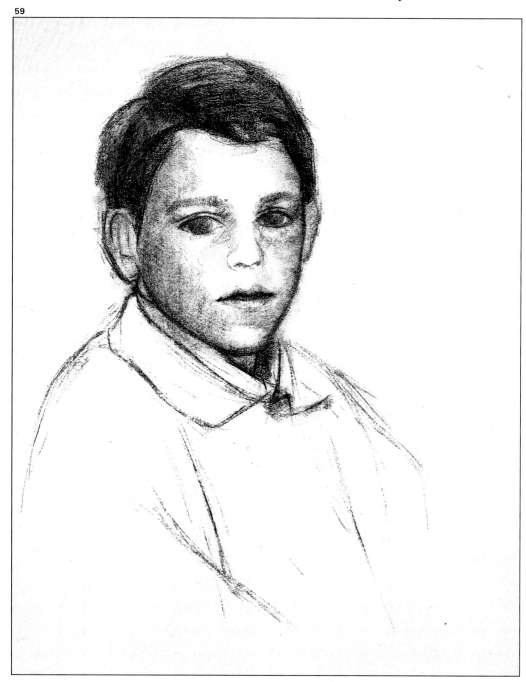

Fig. 59. See how the main structure providing likeness has now been attained, the overall values that define the volume of the hair and the shape of the eyes, mouth, nose, and ears, and even a suggestion of the texture of the skin. Observe this step carefully, with the portrait about to take on a definitive form. Try to guess what the artist will add, a good exercise in imagination and in how to finish off a good drawing.

Step five: strengthening contrast

Let's take a look at the portrait. The features have to be brought out more. In the language of art, this means interpreting form in terms of surface and volume: the different planes of the lips, the surrounding lines, the darkness of the eyes, and the inside of the mouth. We also need to give more body to the hair on the left, refine the subtle changes in tone of the cheeks and cheekbones ... build and build.

Serra has now highlighted the contrasts, so that the blacks of the eyes and the mouth are full of expression. As well as leaving parts of the body only hinted at, she has also even left parts of the head less than fully defined. The right ear, for example (that is, Héctor's left ear, which appears on the right to us), gives depth without making the portrait overdone. Just one expressive line can indicate perspective and volume, as the artist herself explains: "If I round off the right-hand side of the face too well, I lose depth."

We can also see that the artist has strategically placed one or two shaded areas over the jersey, giving the portrait its "shade rhythm," relating the face to the clothes, which are merely suggested by a series of pencil strokes and were in danger of being lost completely in the overall perspective of the drawing.

The portrait is finished. We all agree that it is a fine piece of work, rich and expressive as well as a good likeness. Esther Serra signs her work, and we leave her still wondering whether the portrait is really finished. Of course it is!

Fig. 60. Serra uses the eraser with great care, just to tone up a line of the chin and to add a clear spot to the construction of the right cheek.

Fig. 61. Still using the eraser, she shapes the eyebrow and the values of the forehead, giving form and volume to the head.

Fig. 62. Serra creates different values, variations of gray that set each other off. She removes pigment with her finger, which picks up charcoal very easily, and cleans her finger before removing more.

Fig. 63. She fixes the picture, not because it is finished, but so that the black holds and she can work over it without any undesired rubbing or erasing.

Fig. 64. Esther Serra's relaxed, thoughtful, constructive style has given us a valuable drawing lesson. She has been mindful of the overall effect of her picture throughout the drawing process. Her decision to leave the clothes merely suggested has been justified, giving a delicate, suggestive air to the portrait. At the end, to put in some darker black in key spots, she has used a charcoal stick and a Koh-i-noor clay, highlighting the model's lively eyes through the addition of some deep blacks and using the eraser to make them shine, defining the volume of the iris.

60
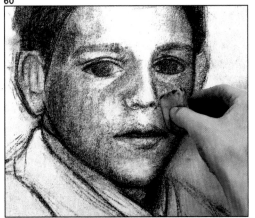

61
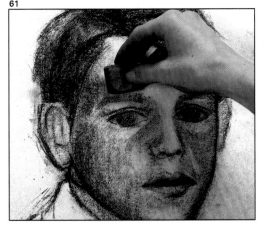

62
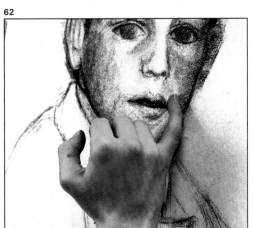

63
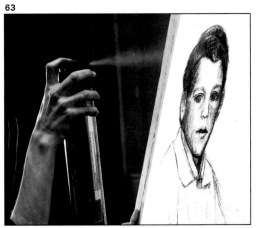

64

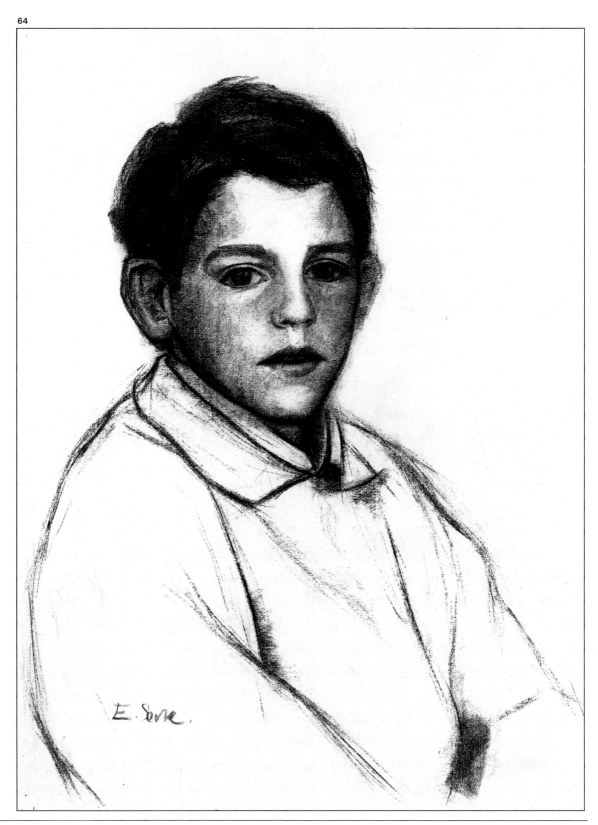

Miquel Ferrón, teacher of drawing and painting

65

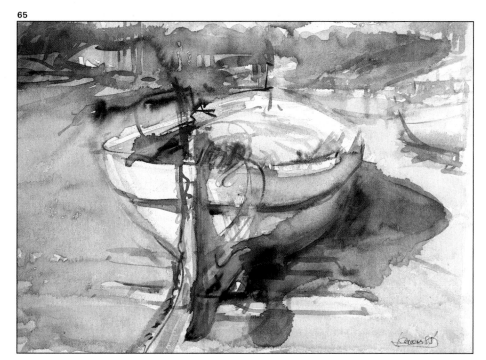

66

Fig. 66. Here is our guest artist Miquel Ferrón, a fine arts teacher whose wide experience in painting and drawing is shown by the illustrations on this page and the next.

67

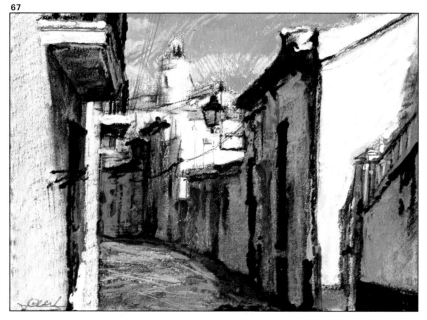

68

Miquel Ferrón, our next guest artist, is a master of every medium for drawing and painting. He teaches at the famous Massana Fine Arts School in Barcelona, which has more than 1,500 students. He is a master of painting and drawing in watercolor, oil, wax crayons, markers, acrylic colors, and pastels. Ferrón is also an expert in the art of airbrush painting and has published two books on the subject. He draws with enviable ease and figurative perfection from real life, as we can see in the sanguine portrait on the next page (figure 70).

69

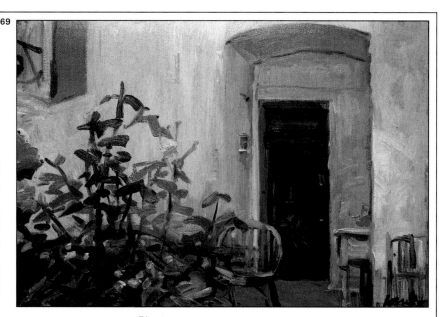

Fig. 65. These two pages show some examples of the skill and variety of the work of Miquel Ferrón, an artist who draws and paints with enviable perfection, and is master of such different techniques as watercolor (figures 65 and 71), wax crayons (figure 67), markers (figure 68), oil (figure 69), and sanguine (figure 70).

70

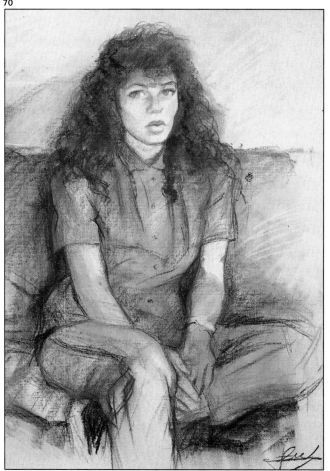

71

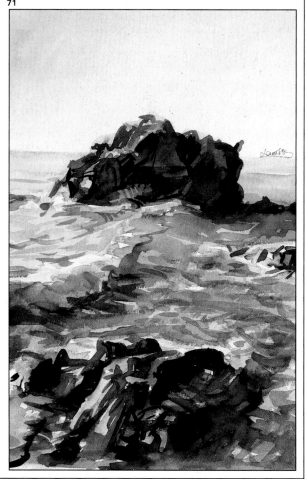

"Very well, I'll draw a portrait of my father."

When I asked Miquel Ferrón to draw the portrait of an older person in wax crayons for this book, he answered delightedly, "Very well. I've often promised my father, who's getting on in years, that I would do a portrait of him, and this is just the chance we've been waiting for."

On the agreed day, we went to Ferrón's studio, and there he was with his father, an older man with slanted eyes, a wide forehead, a large nose, sagging cheeks, and wrinkled skin.

So here we are. Ferrón asks his father to sit down in an armchair near the window and tells me he is going to draw with natural light falling on his subject from a lateral direction. He sits down about 5 feet (1½ meters) from his father. He then clips his drawing paper to a board, which he leans against the back of a chair. "I'm going to draw the head only," he says.

His paper is a special textured imitation canvas measuring 20 × 28″ (50 × 70 cm).

72

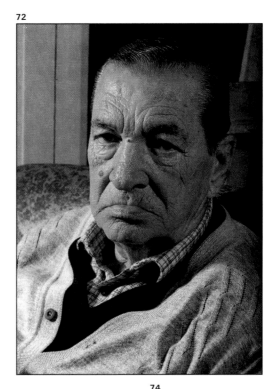

Fig. 72. This is the model, the artist's father. The features of this 78-year-old man bear the characteristic marks of age. At first, Ferrón chose lateral lighting, which he subsequently changed for backlighting, as we will see in the following pages.

Figs. 73 to 77. Ferrón draws with extraordinary confidence, first sketching in the structure or framework of the model with faint lines he later draws over and reinforces with the definitive outline, as we can see from the portrait as it stands at the end of the first phase (figure 77).

73

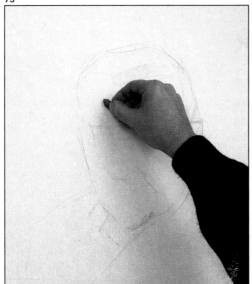

74

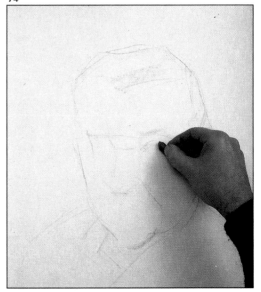

Next to him, on his right, there is a small table for his materials: wax crayons, a bottle of turpentine, and a cloth. He uses the most basic materials, with neither a pencil for the preliminary sketches, nor an eraser, nor a white crayon, nor a paintbrush, nor a cup for the turpentine. He has chosen just six colors: black, dark gray, English red (equivalent to sanguine), crimson, light cobalt blue, and dark ultramarine.

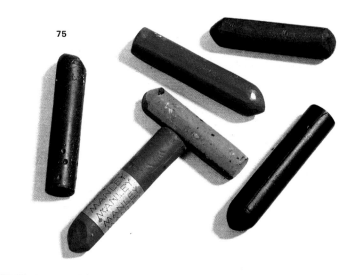

"You're working with very little in the way of materials," I say to him. "You're not even using white, which I would have thought you need in working with wax crayons, to blend and harmonize, especially as you're working with such a soft brand of crayons."

Ferrón has already started the drawing with the sanguine crayon. "I'm going to blend and harmonize with turpentine," he says. "And if you draw lightly at first, with just a few soft lines you can strengthen later, and you can do without pencil and eraser. (Figures 73, 74, and 76 illustrate the soft lines he's talking about.)"

Accordingly, Ferrón completes the first phase of the portrait with a linear drawing, going over the lines repeatedly, but reproducing the head and face of his model perfectly, as we can see. Figure 77 shows the drawing as it stands at the end of this first step.

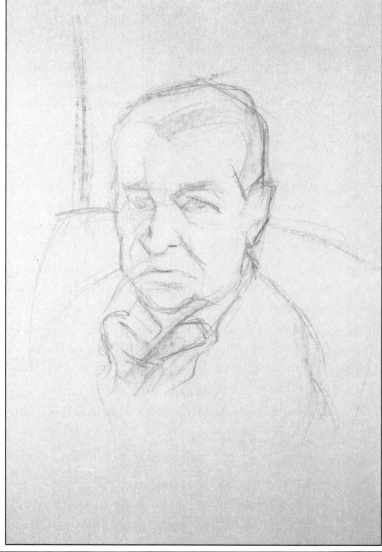

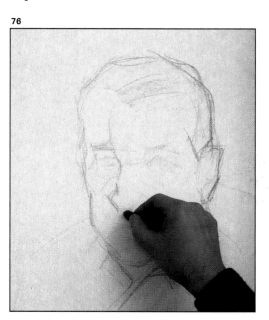

Fig. 75 (above). These are the colors Ferrón has chosen for painting the portrait of his father: black, dark gray (which looks almost greenish in the photograph), red or sanguine, crimson, light cobalt blue, and dark ultramarine.

A portrait drawn in color

Miquel Ferrón continues working with the sanguine crayon. He is still at the initial stage, strengthening and reinforcing, now working on the likeness with the dark blue crayon.

He has asked his father to sit a little forward in relation to the light of the window, so that the model's head is illuminated more from the back than the side. The artist is quick to explain this change.

"I think backlighting or semi-backlighting is better for a portrait of an older person like my father. It's the best lighting, to not exactly hide, but to soften lines and wrinkles and the sagging flesh of the face."

And he goes on working, defining the line that will mark the change from light to shadow caused by the backlighting (indicated by the arrow in figure 81).

The extraordinary ease with which Ferrón draws that most difficult of subjects, the portrait, makes me exclaim, "You do a lot of drawing, don't you?"

"Yes, I draw all day, giving classes, teaching, correcting. But, really, as you know, the face of an elderly man is relatively easy to draw, much easier than that of a young woman or a child. Because, of course, in the features of that face," he goes on, pointing at his father's face, "there are characteristics like lines, bags, and wrinkles that help you work out dimensions and proportions, the basic structure, the whole drawing."

78

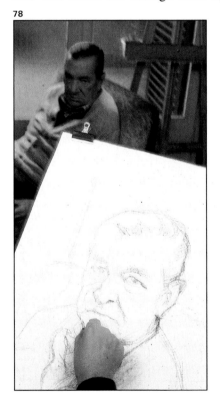

79

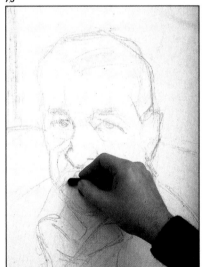

80

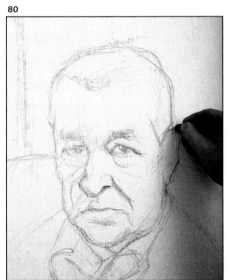

Meanwhile, the photographer and his assistant capture the step-by-step development of the portrait. As he works, the photographer becomes intrigued and asks, "Why are you only using just these six colors?" Ferrón smiles and replies:

Figs. 78 to 80. Miquel Ferrón now works in dark ultramarine, reinforcing and capturing the definitive linear drawing for the portrait of his father.

81

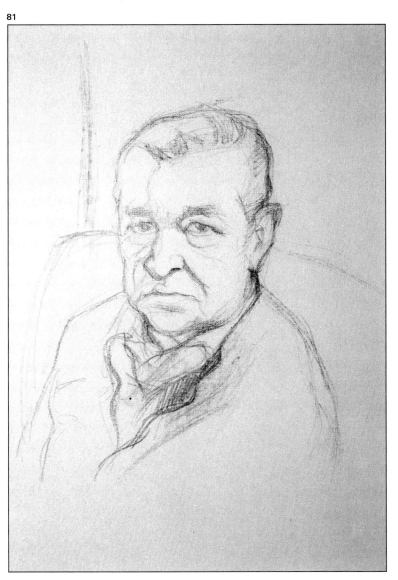

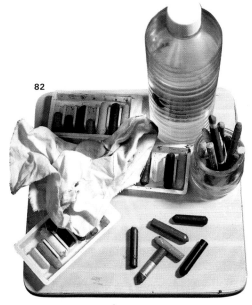

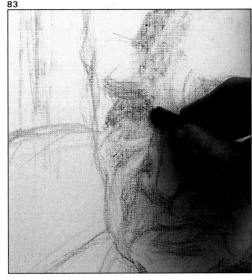

"Well, Parramón asked me for a wax crayon drawing. A drawing, not a painting," he stresses. "So I'm drawing, painting with all the colors I need, but few enough that the portrait of my father will really be a drawing."

Fig. 81. By the end of this second step, we can see how the dark blue has been used to strengthen and define Ferrón's construction, and to determine the line on the forehead where the light meets the shadow cast by the backlighting. (See arrow marked A.)

Fig. 82. Here are all Ferrón's materials for this portrait: a limited number of wax crayon colors, turpentine, and a rag.

Fig. 83. In this photo, we see how Ferrón begins to resolve the shadows cast by the backlighting he is working with, once again using his sanguine crayon.

Steps three and four: modeling with sanguine and blue

84

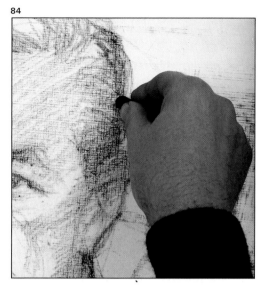

85

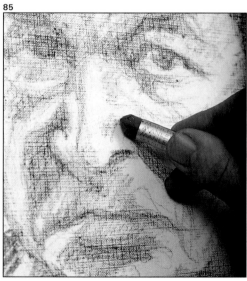

86

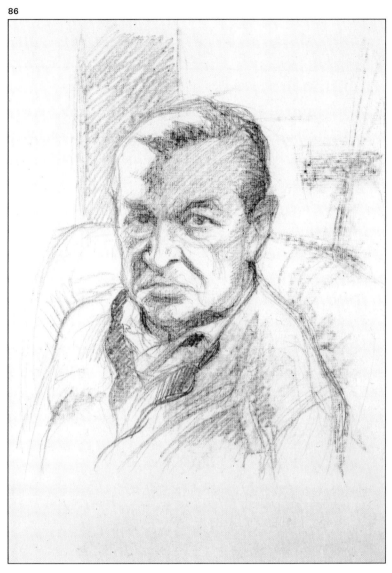

Here is a practical exercise to help you learn to paint while drawing, an exercise frequently used in art classes. Draw with two colors, just two colors, which must be as follows: (a) ultramarine and (b) raw sienna, English red, Indian red, or sanguine—it does not matter which. These color pairs can give you a wide range of colors and luminous tones, ranging from an almost electric red and a luminous dark sky blue separately, to an enormous range of grays and dull colors, either warm or cool, when mixed.

If the reader has never tried an exercise of this type, we strongly recommend it as a perfect first step to learning how to paint.

Ferrón, meanwhile, has begun and ended these phases, drawing and painting, strengthening, portraying the play of light and shade, creating and reinforcing contrast —the light on the left-hand side, so typical of backlighting—and has practically resolved the basics of the portrait with just two colors, sanguine and blue.

Figs. 84 to 88. Alternating between sanguine and dark ultramarine, painting and drawing at the same time, Ferrón completes the second and third steps in his work. To draw the face, he mixes sanguine and dark blue, heightening the bluish effects in the areas touched by the reflected light, and drawing the shadows of the model's clothes almost entirely with blue. Ferrón's drawing is taking on a greater and greater likeness to his model.

87

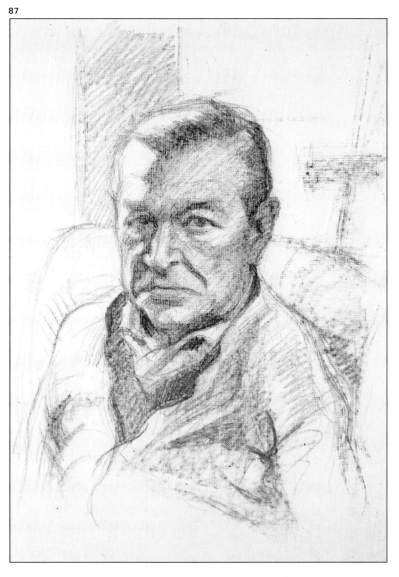

88

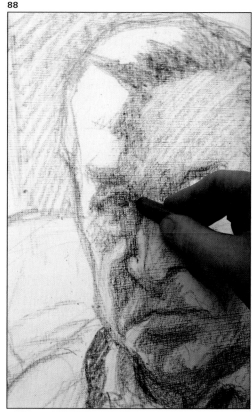

And now that he has captured the structure and the likeness, Ferrón is going to paint the drawing, intensifying tones and colors, adding crimson, gray, and black, blending and harmonizing colors with the help of his bottle of turpentine. But this step belongs with the text and illustrations on the next page.

Step five: intensifying and harmonizing colors

Figs. 89 to 92. Wax colors are easily dissolved by rubbing with a cloth and some turpentine. All you have to do is to rub with the cloth over an area painted with wax crayons, as we can see in these illustrations. This technique allows you to blend and harmonize colors, smoothing over outlines to achieve a texture or coloring reminiscent of the effect of gouache or watercolor.

Fig. 93. Study Ferrón's portrait at the end of step five. You will notice the results of the artist's technique of using turpentine to dissolve and blend wax crayon colors. Look especially at the forehead, the nose, the cheek, the cheekbone, and the jaw—and at the creases and folds of the clothes. Even the back of the chair to the left of the model's profile has been blended with turpentine. By rubbing and dissolving more here, less there, Ferrón has achieved overall a different form of expression within the limits of wax crayons.

89

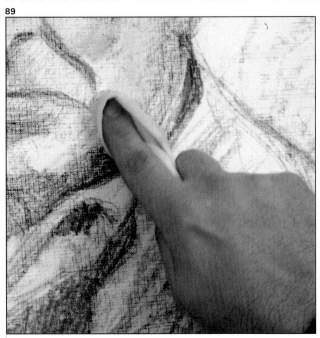

90

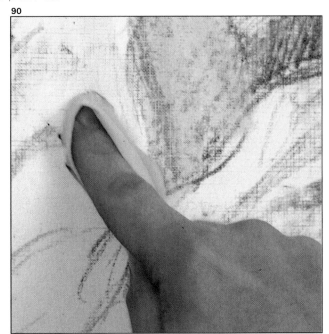

91

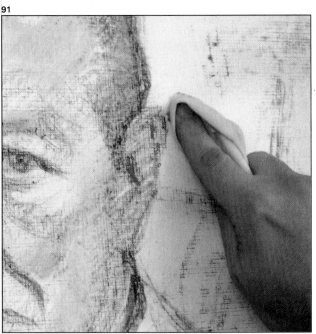

92

93

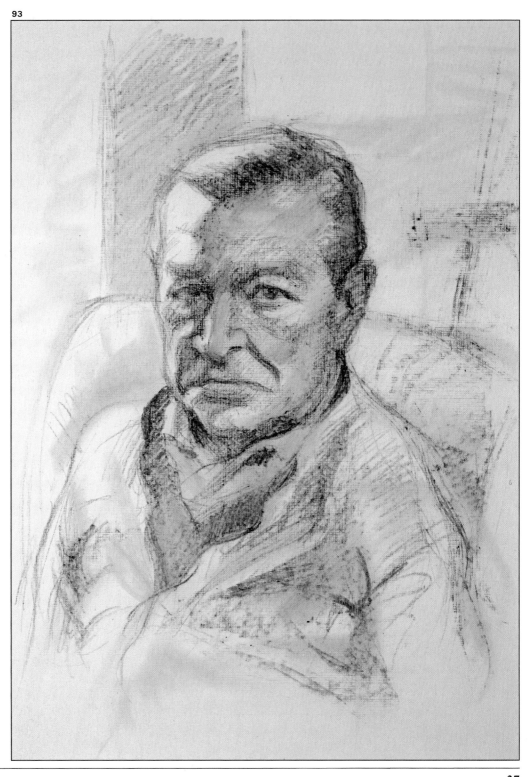

Step six: finishing touches

94

95

Figs. 94 and 95. Here we can appreciate the texture of the special paper with its characteristic imitation of a painter's canvas. "The relief of this texture, imitating that of canvas," Ferrón stresses, "and its stiff sizing make it the ideal paper for painting with wax crayons, giving a less-finished, looser, more artistic finish." Certainly, we agree, but without forgetting that Ferrón's expert drawing technique also contributes to this looser, more artistic finish.

Fig. 96. Drawing and painting at the same time, Miquel Ferrón has brought his portrait to the point where it now expresses the two basic conditions for a good portrait, which are explained in the introduction to this book.

96

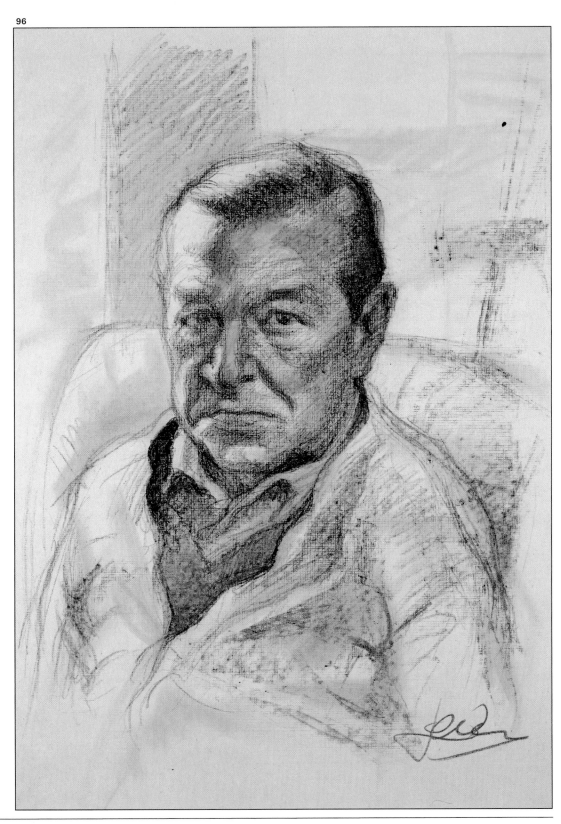

The portrait and the human head

Among the more than thirty books on drawing and painting published by José M. Parramón there is a volume on the art of drawing portraits, which also includes a section on the construction of the human head and how to draw it. The title of the book is *How to Draw Heads and Portraits*, and it is also published in English by Watson-Guptill Publications. Here Parramón emphasizes the importance of practicing drawing the human head in order to master the art of the portrait.

"To become aware that there are ideal dimensions and proportions that can often be applied to the drawing of a portrait, to the person we are going to draw, you have to study and know the canon of the head seen in profile and from the front. I strongly recommend that you study the formula of this canon." (See page 5.)

But let us begin by looking at the materials needed for a portrait in lead pencil.

Materials

You can see the materials I will use in figure 98. First and foremost is the lead pencil, now available in two versions: the classical wooden lead pencil and the all-lead stick, made completely of lead to the same diameter as a normal pencil. As you know, both types are available in a wide range of degrees of hardness. To draw this portrait I will work with soft 3B and 6B pencils, and for retouching and finishing touches, a 2B pencil, which does not appear in the photograph.

Fig. 97. José M. Parramón is now going to draw a portrait in lead pencil.

Fig. 98. These are his materials: soft 3B and 6B lead pencils (both wooden and all-lead), as well as stumps, two erasers, and several tools for keeping his pencils sharp. The artist is going to use Shoeller drawing paper.

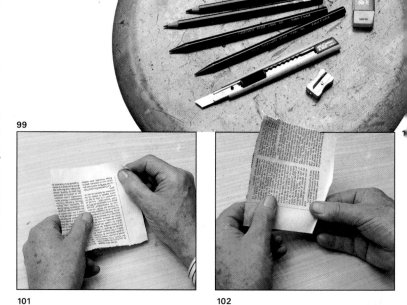

Figs. 99 to 102. These pictures show how to make a special, extra-thin stump, using a small piece of newspaper.

103

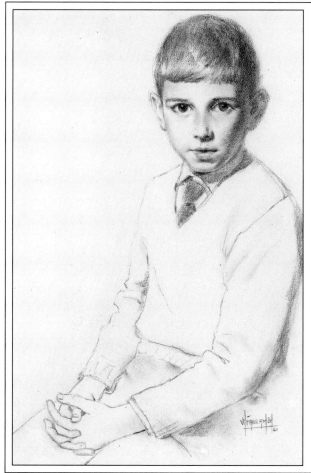

104

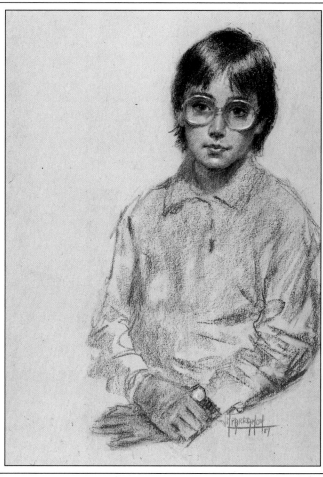

I will also use rubber erasers (generally not too hard), paper stumps, and a cutter and sandpaper to sharpen the lead, or a pencil sharpener, which is best for sharpening all-lead sticks. Notice the special stump you will see me use in my portrait; being very thin, it is just the thing for blending small details. You cannot buy this kind of stump at the store, but you can make it yourself using a strip of newspaper, a spongy type of paper similar to that from which stumps are generally manufactured.

The pictures on the previous page will show you how to make your own stump.

First, cut out a piece of newspaper measuring about 5'' (12 cm) square, and roll up one end (figure 99). First use the thumb of one hand to do the rolling (figure 100), then the thumbs of both hands, almost as if you were rolling a cigarette, but rolling one end more than the other (figure 101), until one end of the strip of paper resembles figure 102. Fasten the end you have rolled up with adhesive tape, and you will have a stump with a fine point, ideal for touching up small details.

I am using Schoeller drawing paper, a little over half a sheet.

Figs. 103 and 104. Various mediums can be used to draw a portrait. Here, Parramón has drawn with lead pencil on white paper (figure 103), and with sanguine, charcoal, and white chalk on colored paper (figure 104).

"Examining" the model through sketches

105

106
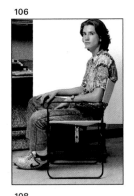

107
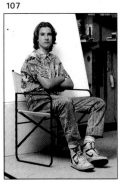

108
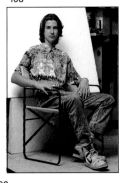

109

110
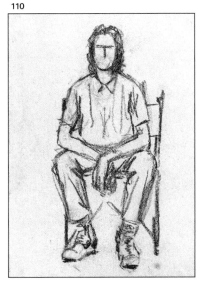

111
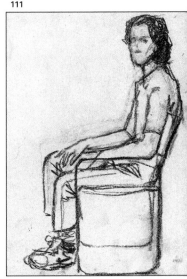

112

113

The first session for this lead pencil portrait finished without my beginning the portrait itself. I already knew the model, but I chatted with him for some time, first about everyday things and later about the portrait: the pose, the fact that I wanted him to feel comfortable, how long it would take to complete the drawing, and the fact that first I would do some preliminary sketches. This gave me the chance to get to know him better and to study physical characteristics, his physiognomy and features. After this, the model started to get into a variety of poses while I began to "examine" him in a different way, this time through sketches. I did five or six sketches of different poses, four of which are reproduced here.

The most suitable pose seemed to me to be with the model sitting on a stool. It was the most natural and relaxed, and suited his age and character.

Each sketch of the different poses took about five minutes to complete, so I found myself at the end of the first session having gotten only as far as deciding the pose for the portrait itself—which is actually excellent progress!

Figs. 105 to 109. Here is the model in some of the poses studied.

Figs. 110 to 113. And these are some of the sketches drawn by the artist in the first session, which was dedicated entirely to experimenting with poses and to "examining" the model through sketches like those shown here.

Step one: the basic structure

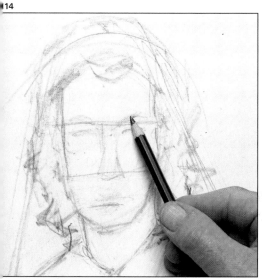

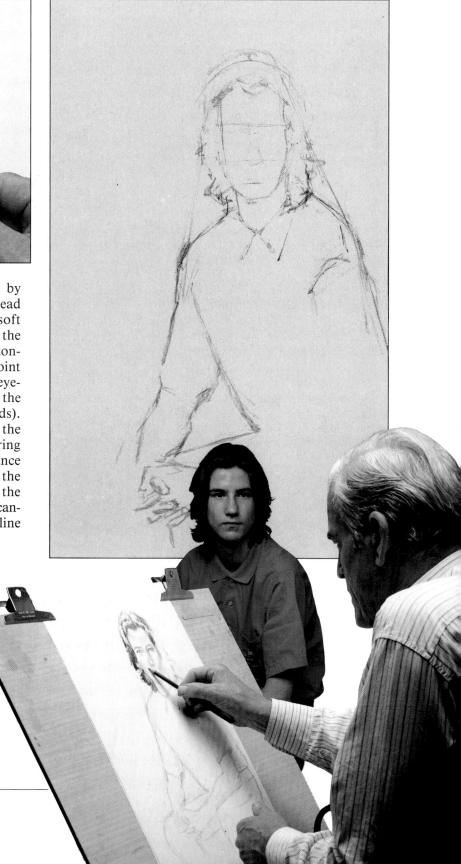

The next day, I began the portrait by drawing the structure of my model's head and body lightly on the paper with a soft 3B pencil. I drew an oval to represent the shape of the head, then put in the horizontal lines of the canon to indicate the point where the hair begins, the height of the eyebrows, the lower part of the nose, and the chin (or the point where the face ends). Almost instinctively, I also calculated the distance between the eyes, remembering that, according to the canon, the distance between the eyes always corresponds to the length of one eye. Still remembering the ideal dimensions and proportions of the canon, I lightly drew in the mouth, the outline of the hair, the neck, and the body.

Fig. 114 (above left). The drawing of the actual portrait begins. Parramón uses as a starting point the linear reference of the canon of the human head.

Fig. 115. We can see here that the general structure of the head and body are drawn in from the start.

Step two: sketching the eyes, the nose, and the hair

After structuring the head and body of my model, I begin to work on his facial features—drawing lightly, exploring and sketching. I vary the way I grip the pencil, sometimes holding it the normal way, and other times holding the stick inside my hand.

I start with the eyes, following Ingres's advice and "skimming" over this part of the face, building up the picture as I go on, sketching the shape of one eye, then moving over to the other, leaving that one to work on the nose, then going back to the first eye, and so on, not just concentrating on one eye or form in particular, but building up the whole picture.

Bearing this in mind all the time, I draw with the pencil, immediately using my fingers to blend what I have drawn, resolving the form of the eyebrows, the eyelids, the nose, the cheeks. This is my first approach to the features of the face, and I am still drawing lightly, not yet putting in any dark tones, so that I can strengthen or correct my work later if necessary.

And now I start working on the hair, holding the wood of the pencil inside my hand. By drawing with the sides of the lead rather than just the point, I achieve thicker lines and gray and black shading.

116
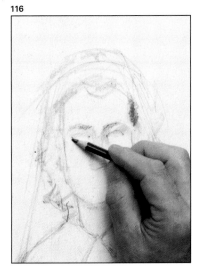

117
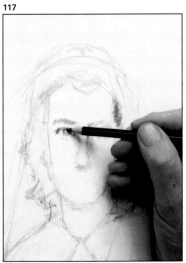

118
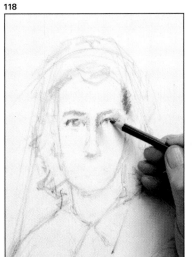

119
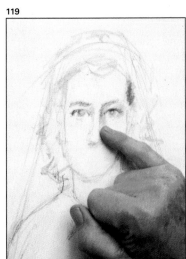

120
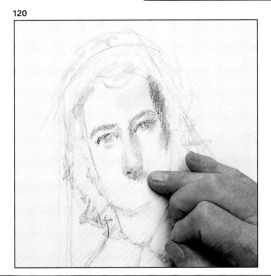

121
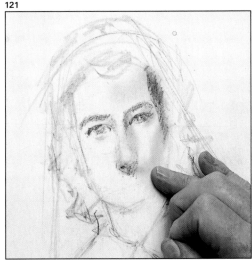

Figs. 116 to 121. With the 3B pencil, Parramón sketches the eyes and the nose, drawing faint lines to catch their form and beginning to model by blending with his fingers.

122

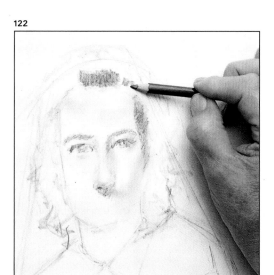

The direction of my lines is now determined by the direction in which the hair has been brushed, and the highlights and reflections in it. The intensity of tone in the hair is rendered by light and medium grays in consonance with the features, which are still quite lightly drawn.

In the reproduction of the portrait as it stands at the end of this step, you can see that it has the finish of a sketch, and that the eyes, the nose, and the hair are still in the planning stage. It is a half-finished work, yet one that offers, in the words of Ingres, "the likeness that is to be brought to perfection at the end."

Figs. 122 to 125. Parramón immediately goes on to sketch in the shape of the hair, drawing in the direction that the hair is brushed. At the end of this phase (figure 125), you can see the general structure of the body and the head, as well as the initial drawing of the facial features.

123

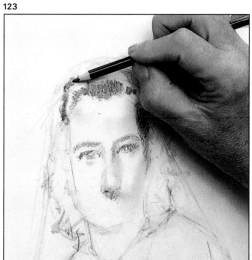

124

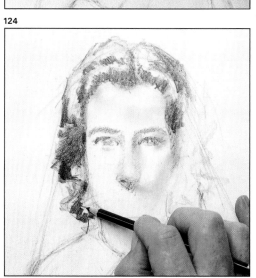

125

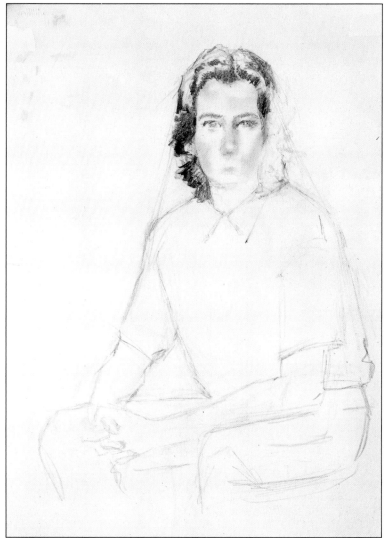

Step three: drawing with the fingers, the eraser, and the stump

Figs. 126 to 131. In this sequence, you can see how to draw with the pencil, blend and draw with the fingers, and "draw" with the rubber eraser (figure 130), which has previously been shaped into a point (figure 129).

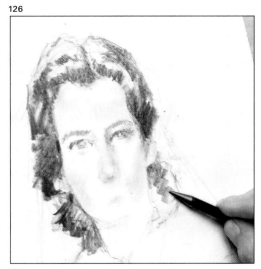

126

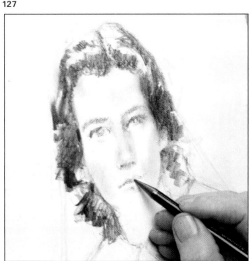

127

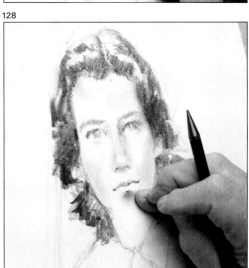

128

If we compare the results at the end of this stage, shown in figure 135, with the results at the end of the previous one, reproduced in figure 125, we will not see great differences. A few lines have been added to the hair to give it more darkness; the mouth and chin, while still far from finished, have advanced noticeably; and a little light shading has been added to the cheeks, jaw, and chin. But, even though these changes do not seem too remarkable,

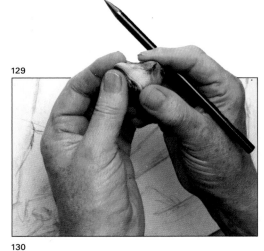

129

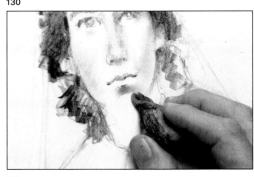

130

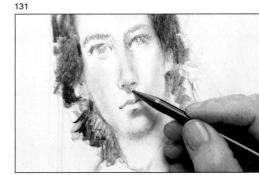

131

it will be worthwhile explaining how I went about adding them to the portrait.

In the first place, note that I have been drawing with the all-lead stick, the soft 3B. With this, I draw first the mouth and the gray area or shadow below the lower lip. Then, with my finger (figure 128), I blend it without worrying, for now, about whether I am overdoing it. Next I make a cone shape out of the soft eraser. (As you know, this eraser is somewhat similar in its malleability to Plasticine.) You can see how I do this in figure 129. With this cone-shaped eraser I create the curved line on the chin where light and shade meet (figure 130). Then, with the pencil, I work on the shape of the

nose, and put in the shaded area at the bottom of the chin, blending and drawing these areas in with my fingers.

In figures 132 to 134, you can see how to draw with the stump: First, I darken the black of the hair using the 6B all-lead stick. I then collect some of the lead I have deposited on the stump in darkening this area, and proceed to "paint" with the stump, intensifying the soft shading of the lower part of the face.

Figs. 132 to 134. To add grays and subtle shadows, in this case on the cheeks and chin, Parramón first blackens with the all-lead pencil, then loads the stump with the lead deposited in the process of blackening, and finally uses the stump to draw.

Fig. 135. At the end of step three, the portrait is already beginning to take on a certain likeness to the model.

132

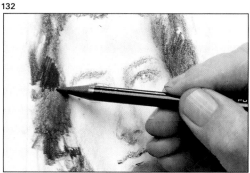

133

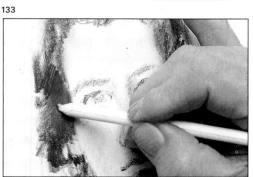

134

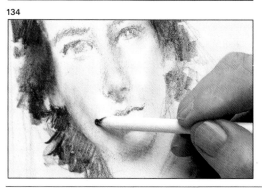

135

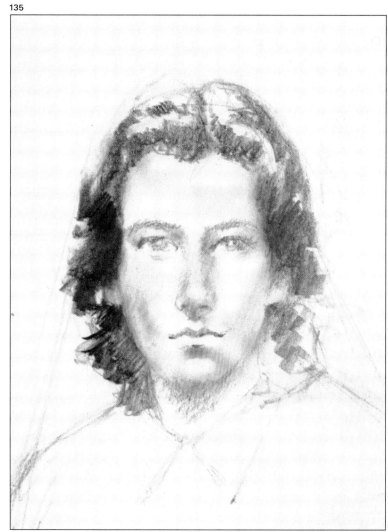

Step four: adjusting the likeness

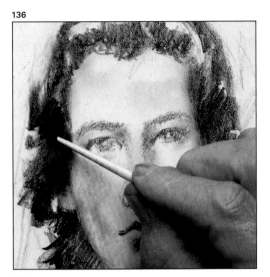

136

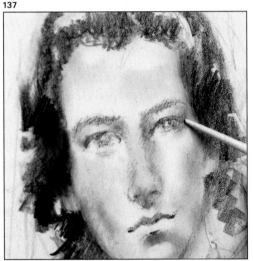

137

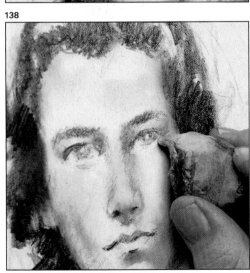

138

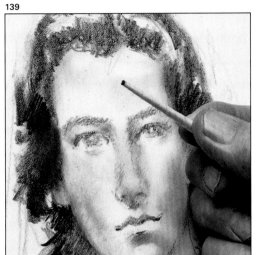

139

Figs. 136 to 140. At this stage, the structure of the drawing has been defined. Light and shade have been sketched in, and the drawing has now established some degree of likeness to the model and of artistic quality. Both likeness and artistic quality must now be perfected, dimensions and proportions must be adjusted, and the play of light and shade must be heightened through contrast.

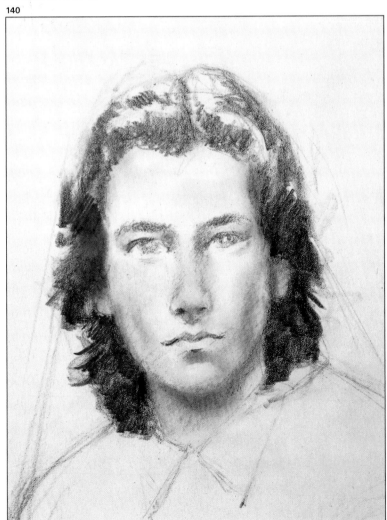

140

In this stage, I continue working on the head, the face, the features, and the likeness. As you can see in the finished portrait (page 51, figure 150), the center of interest of the whole drawing is the head itself.

It is time now to adjust the likeness by adding to, rubbing out, or rectifying the form with the 3B all-lead stick and the soft eraser. I will also use my finely pointed homemade stump to draw or intensify the small forms, grays, and gradations that subtly influence the likeness of the portrait to the model. You can see the technique for charging the small stump with lead from a shaded area, then drawing faint lines with it, as we already saw on the previous page.

Now there is just one more session before the portrait is finished.

Figs. 141 and 142. Parramón begins the task of adjusting forms—small, almost imperceptible shapes—using grays and gradations that will clarify the likeness and enhance the quality of the portrait.

Fig. 143. With all the work so far concentrated solely on the head, this fourth phase shows the unfinished appearance of the portrait at the end of the penultimate session, when the artist must draw "thinking out the stroke," as Picasso said, observing and calculating, comparing the forms of the model with those of the portrait.

141

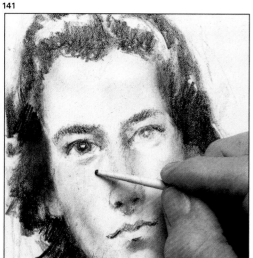

142

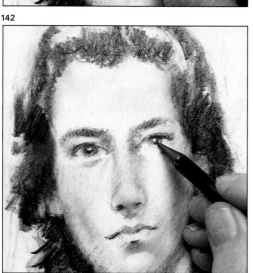

143

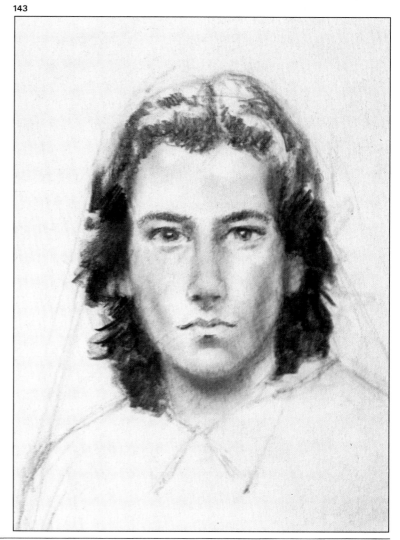

Step five: finishing the head and drawing the body

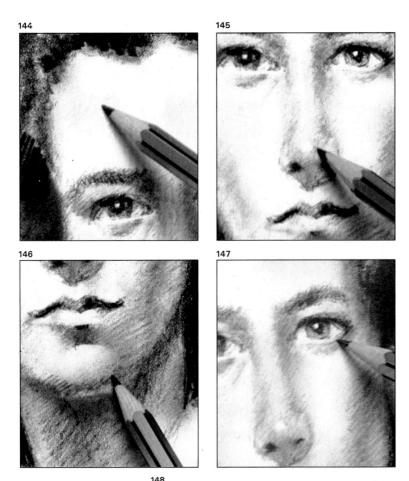

144

145

146

147

To finish off the head, I will work entirely with the 2B pencil, which, though soft, is a little harder than the 3B and 6B I have used up to this point. The 2B is principally used to retouch, to harmonize grays and gradations without blending, so that the pencil line shows through the earlier work. You can see the effect of these finishing touches in the details shown in figures 148 and 149. Now on to the body. The hands require special attention, almost a draftsman-like work. The body in general must be rather understated so as not to distract attention from the head, the real subject of a portrait.

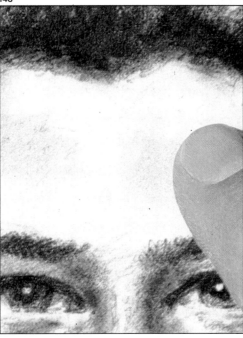

148

Figs. 144 to 148. The final job of adjusting and retouching, balancing intensities and contrasts, adding the finishing touches, is done almost entirely with a softer pencil like a 2B.

Fig. 149. In this close-up view you can see how the artist resolved the delicate shadows around the eyes and nose.

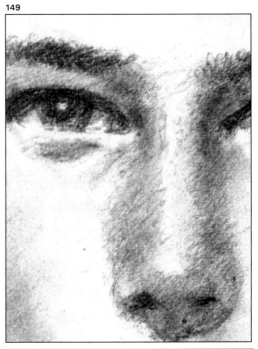

149

Fig. 150. The body and the hands have now been drawn in a more linear, secondary way, so as not to distract from the head and face. This forms part of a classic style that we can see in the portraits of Ingres and many of the impressionists. ''I believe that it is the ideal formula for a portrait using this medium,'' Parramón declares as he signs this portrait with lead pencil.

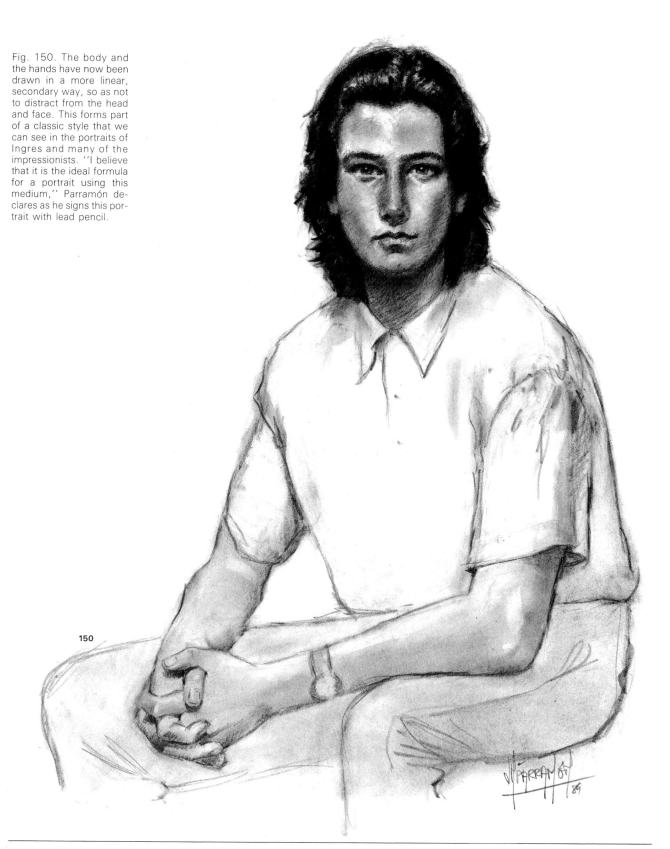

150

A portrait "à trois crayons": the artist and his materials

151

152

153

154

Joan Sabaté, a well-known artist and fine arts teacher, is going to draw and paint a portrait in the classic three crayons for us.

Sabaté is an expert in the art of drawing portraits and, as such, is fully equipped with materials, such as the materials box shown in figure 153. "I designed and built it myself," Sabaté tells me. Apart from the ashtray with more than fifteen cigarette butts (Sabaté smokes cigarette after cigarette while he works), the box contains a wide range of sanguine and sepia chalks, charcoal sticks, erasers, stumps; there is also a small palette and much more. The materials Sabaté is actually going to use for this portrait are shown in figures 152 and 154: an easel with board and a sheet of cream-colored Canson demi-teintes paper, chalk and sanguine (in both pencil and stick form), a stump, a pencil sharpener, sandpaper, a black woolen cloth, and two items that deserve separate mention: an eraser pencil whose "lead" is made up of rubber (the blue pencil on the left with the white "lead"), and an aerosol spray (the metallic tube on the right), containing hairspray, which Sabaté uses as a fixative.

Fig. 151. Joan Sabaté is a painting and drawing teacher who specializes in the art of the portrait. He is going to draw for us a portrait "à trois crayons," that is, using charcoal pencil, sanguine and sepia sticks, and pastel pencils, and highlighting with white chalk, on cream paper.

Figs. 152 to 154. Here are the materials Sabaté will use to draw this portrait "à trois crayons."

Joan Sabaté: a professional portrait artist

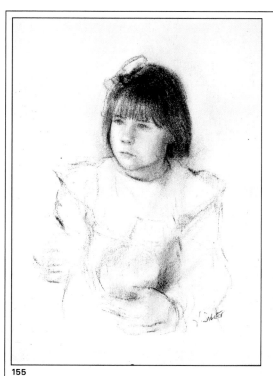

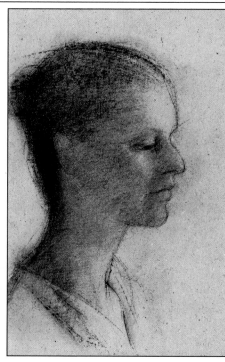

Figs. 155 to 158. Here are several examples of portraits by Joan Sabaté: Figure 155 is a charcoal pencil drawing on white paper. Figure 156 is a portrait in charcoal on yellow ochre paper. In figure 157 you see a portrait in charcoal and sanguine, sepia, English red, and white chalks, achieving results similar to those of a pastel drawing. Finally, figure 158 is a work by Sabaté mainly using white chalk and sepia pencil with some touches added in charcoal pencil.

155

157

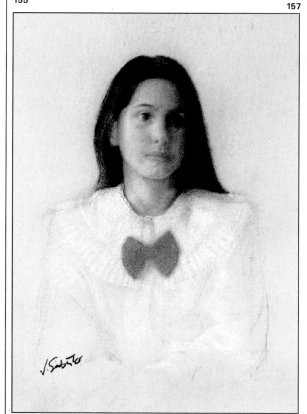

158

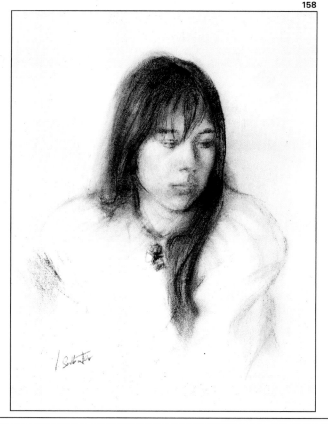

The model and the pose

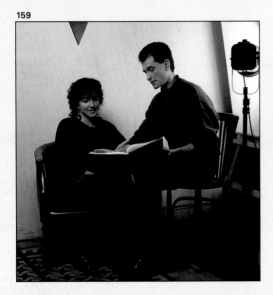

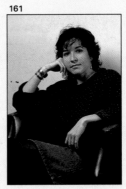

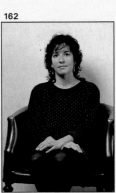

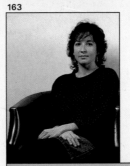

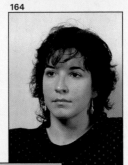

We are in Joan Sabaté's studio. Sabaté is going to study and decide the pose for his portrait. First, he talks to the model, getting to know her, explaining exactly what a portrait is, and what it can be. He studies her gestures and features to capture her character and physiognomy. Next, the model sits down near the easel, first facing straight ahead, then resting her head on one hand, then with her hands crossed, next with her body turned to one side and the head facing forward, and so on, as we can see in figures 160 to 167.

Sabaté studies each of these poses and asks the model to change the position of, for instance, her head, one of her hands, one arm. Meanwhile he imagines forming a sort of rectangle with his hands, as in figure 171, and finally chooses a pose—the one you can see in the enlarged photos shown in figures 166 and 167. The artist explains, "It is important to study and try out different poses, looking for the one that best expresses the model's character, and the most aesthetic one. It is also important to make a few

Fig. 159. As a first step, before studying the pose, Sabaté talks to the model, trying to capture her expression, gestures, and most natural pose.

Figs. 160 to 167. Following Sabaté's instructions, the model gets into different poses, and finally the artist chooses one, the pose shown in figure 166.

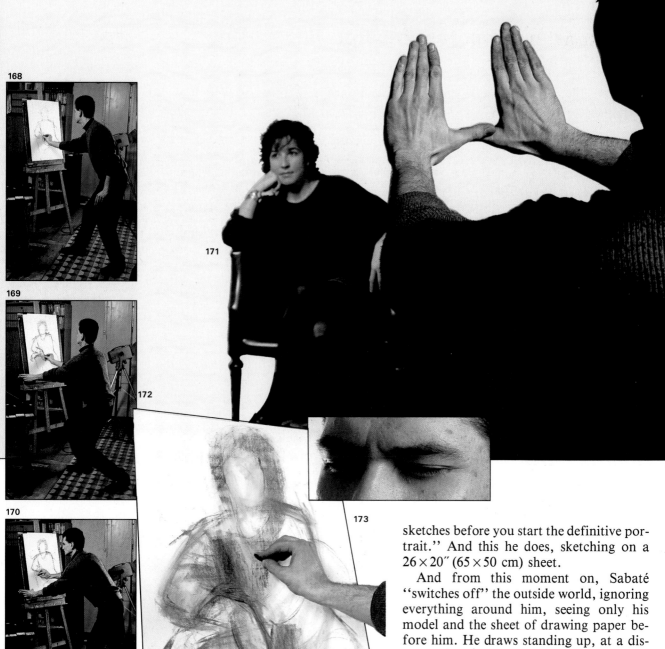

Figs. 168 to 170. Now Sabaté is at work, drawing a preliminary sketch.

Figs. 171 to 173. Sabaté studies the framework of the portrait and makes a sketch, half-closing his eyes to see the model not as a person, but as general shapes of light and dark.

sketches before you start the definitive portrait.'' And this he does, sketching on a 26 × 20″ (65 × 50 cm) sheet.

And from this moment on, Sabaté "switches off" the outside world, ignoring everything around him, seeing only his model and the sheet of drawing paper before him. He draws standing up, at a distance of 2 or 3 yards (2 to 3 meters) from the model. He half-closes his eyes and stretches out his arm, bending down so that he is almost kneeling and then straightening up again, resting his left hand on the drawing board....

As you can see from figure 173, Sabaté is not worried about the features of the face or achieving a good likeness while he sketches. His only concern is to make a study of the model's pose, to see if this is really the right one for the next piece of work, the definitive portrait.

Steps one and two: the structure, the drawing

Sabaté begins to work on the definitive portrait. For the construction of the portrait, he uses a whole stick of sanguine. I stress the word "whole" because it is more usual to use the end of a sanguine stick, or a small piece, which an artist uses when he paints with pastels. But Sabaté holds the stick of sanguine in a surprising way: sideways, flat against the paper to "build the basket," as Ingres calls the outline of the drawing.

Another peculiarity of Sabaté's technique is his way of blending with a cloth, which is not so strange, except that this particular cloth is an old sock.

"Why a sock and not an ordinary cloth?"

Sabaté stops working, smiles, and explains, "Well, the fabric of a sock is similar to that of a towel, which is, as you know, the best type for blending and rubbing out. It's soft, almost spongy. Besides, the sock has a sort of border at the top, which occasionally and unexpectedly gives you a kind of striated graphic effect which I find really interesting when I'm blending."

Right from the outset, Sabaté pauses over the hands, drawing their structure and giving them an almost definitive form and value, as we can see from figure 175.

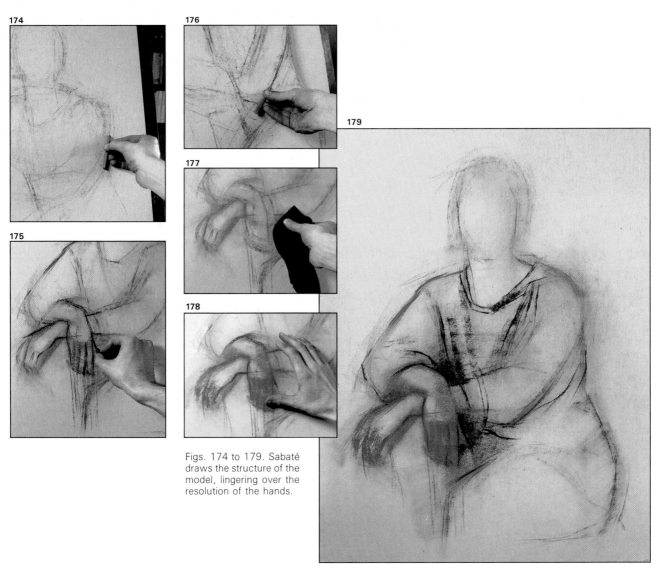

Figs. 174 to 179. Sabaté draws the structure of the model, lingering over the resolution of the hands.

In figures 174 through 176—and especially 175—you can see how Sabaté begins the portrait by first drawing in firm lines with the sanguine, which he then proceeds to blend and wipe away as if dissatisfied with his first effort (figures 177 and 178). Then, over this, he finally draws in the definitive form and construction of the portrait.

In the same way, the artist now works on the face of this model. First he draws with the sanguine, supporting his hand on a wooden rod which he uses as a maulstick (the tool used by oil painters when putting in details over wet paint).

Next he changes his sanguine pencil for a propelling pencil with a sepia Koh-i-noor lead. With this darker color he begins to work on the features of the face. As you can see from the illustrations on this page, Sabaté alternates between drawing with the sanguine or the dark sepia pencils, and blending with his fingers.

"Do you always blend with your fingers?" I ask.

Sabaté replies, while continuing to blend the nose of the portrait with his middle finger, "I usually draw and blend with my fingers, though sometimes I use a fairly thick stump."

180

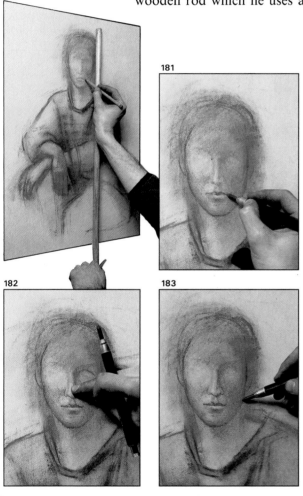

181

184

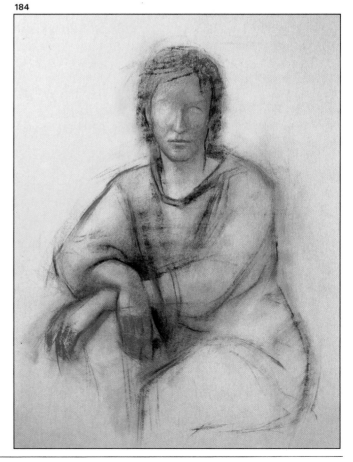

182

183

Figs. 180 to 184. The artist now begins to draw the face, at first with sanguine pencil and a sepia-colored chalk pencil.

Step three: the head and the hands

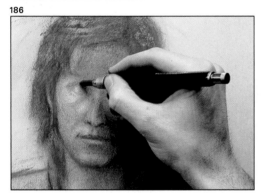

185

Up to this moment, Sabaté has been drawing with his easel placed some 10 feet (3 meters) from the model in order to capture the form and general structure of his subject. Now, however, he is going to concentrate on drawing the features of the face, so he moves his easel closer up to the model—to a distance of about 5 feet (1½ meters). Here he works from a seated position, as you can see in figure 185.

And so he begins working on the features of the face, drawing and blending until he achieves an undefined finish suggesting light and shade seen through half-closed eyes, through a diffused effect of light stains.

"Why is it that up to now you've spent more time on the construction of the hands than on drawing the head?" I ask.

Sabaté gives some thought to this question before answering, "There's no logical or reasonable answer to that. I've been interested in my model's hands from the start, and I thought I could give them the same value as the head and face. So I started with the hands because I felt more comfortable that way. It gave me the chance to experiment and try out different tones, colors, lights, and shades before getting on with the face and head."

186

187

188

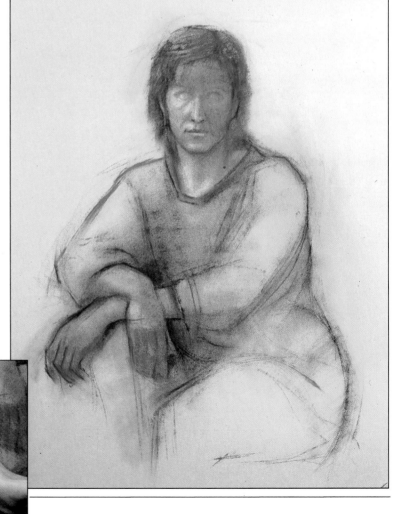

189

Fig. 185. Sabaté moves his easel closer to his model to see and draw the features of her face better.

Figs. 186 to 189. Sabaté continues working on the head and the hands.

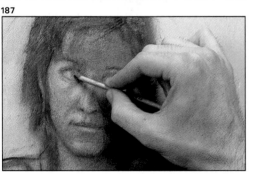

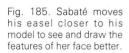

And, as if to back up his words with his deeds, Sabaté goes back to work on the hands, a subject that constitutes a real challenge for the artist, since they cannot be drawn without exactly resolving their form, anatomy, and proportions.

As you can see in figure 188, Sabaté has concentrated on the form of the hands and fingers, drawing and mixing with the sanguine and the dark sepia, blending and resolving value, tending to give this part of the portrait greater darkness. Then he begins to model the hands definitively, drawing with the normal eraser pencil (figures 190 and 191), and adding more delicate lines with his eraser pencil, drawing with it as if it really were a white pencil. In the enlarged photo, (figure 194), you can see the effects of this outlining with the eraser pencil which is a special tool normally used to erase typing.

190

191
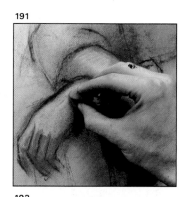

192
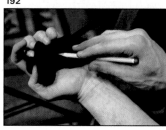

193

Figs. 190 to 194. To perfect his drawing of the hands, Sabaté now uses the eraser pencil to "draw" with.

194
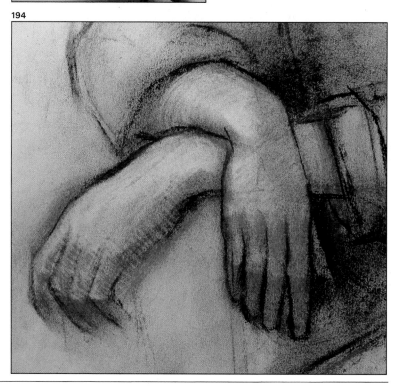

Step four: defining the head

Now Sabaté begins working on the head. He outlines, constructs, blends with his fingers—almost always with his fingers. The head begins to take shape. Then he develops it through shading, darkening it as he did before with the hands, and finishing it with the eraser pencil, as we will see when we come to the last step in the portrait.

Suddenly, Sabaté jumps up, takes a few steps back, stares at the drawing and takes it off the easel. Returning with it to the distance of 2 or 3 yards (2 to 3 meters) at which he started to work, he exclaims, "No. That's no good. I've spent too long over the head and I've overdone it."

I look at the drawing too, and reply, "Well, you haven't finished yet—don't worry." And I add wholeheartedly, "Whatever you do, don't change the body or the hands. It's like a Renaissance painting; it reminds me of a da Vinci."

195
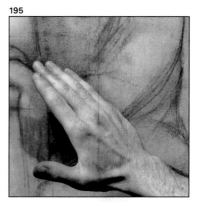

196
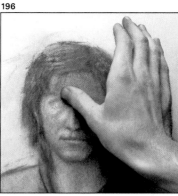

197
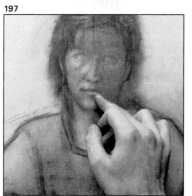

198
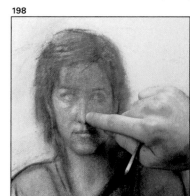

Figs. 195 to 202. After another touch to the hands, the artist focuses all his attention and labor on the head and face. Sabaté brings out the facial features with the sepia pencil chalk and sanguine pencil. He also uses the eraser pencil and blends with his fingers or a cloth.

199
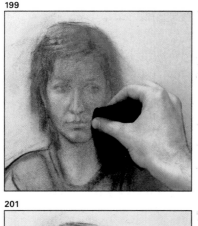

200
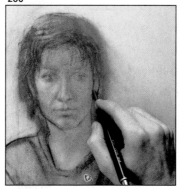

201
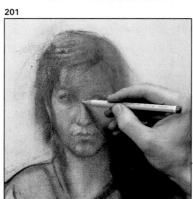

202
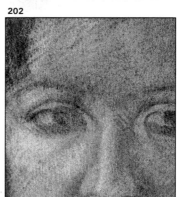

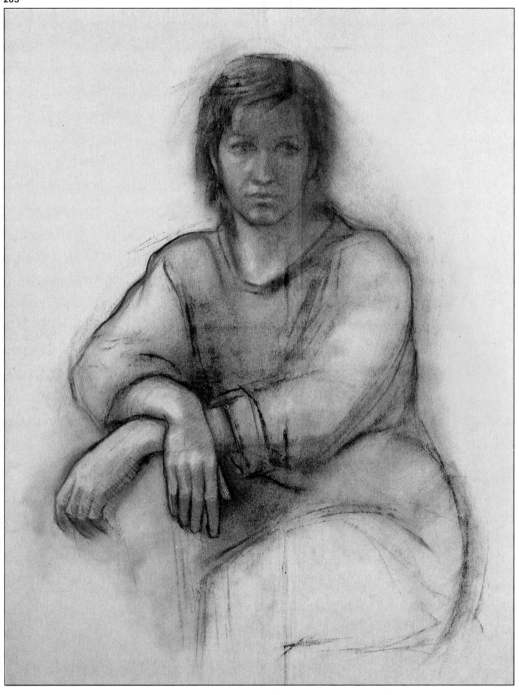

Fig. 203. The body and hands have now been adjusted and are ready for finishing. The head requires refinement of its tonal values and highlights, which Sabaté will soon accomplish with the rubber eraser and the eraser pencil. At the end of this step, the portrait recalls a Renaissance work, more specifically a portrait by Leonardo da Vinci.

Step five: finishing the face

To reconstruct the face and to add the finishing touches, Sabaté uses dark sepia chalk, black charcoal pencil, and the eraser pencil. He performs a general cleaning-up operation, using the eraser pencil to open up white areas and brighten highlights. As he works he softens and blends values, sometimes picking up his dark sepia chalk or the black charcoal pencil to darken a shadow.

Sabaté not only finishes off his drawing of the face, but also reconstructs the dress and the hands, around which he creates contrasts to highlight their form and their whiteness. He also suggests the thigh and the knee, and adds a shaded area behind the waist that improves the composition of the picture.

Figs. 204 to 209. The work of this final session —perfecting the values and likeness of the face— is carried out using charcoal pencil, sanguine and sepia chalk, and the eraser pencil.

Fig. 210. Sabaté's finished portrait is magnificent. He has given a more finished resolution to the head and hands, leaving the rest of the body less sharply finished. This effectively concentrates the viewer's attention on the two most important aspects of his picture. Joan Sabaté's portrait unites the two fundamental conditions of a good portrait: achieving an exact likeness and being, in itself, a work of art.

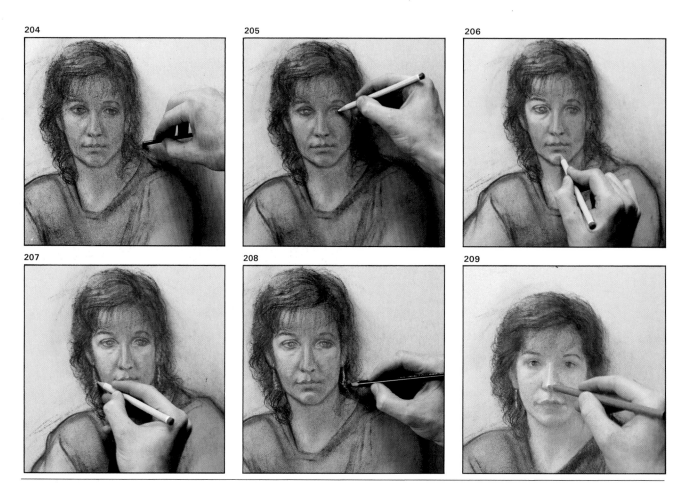

204

205

206

207

208

209

210

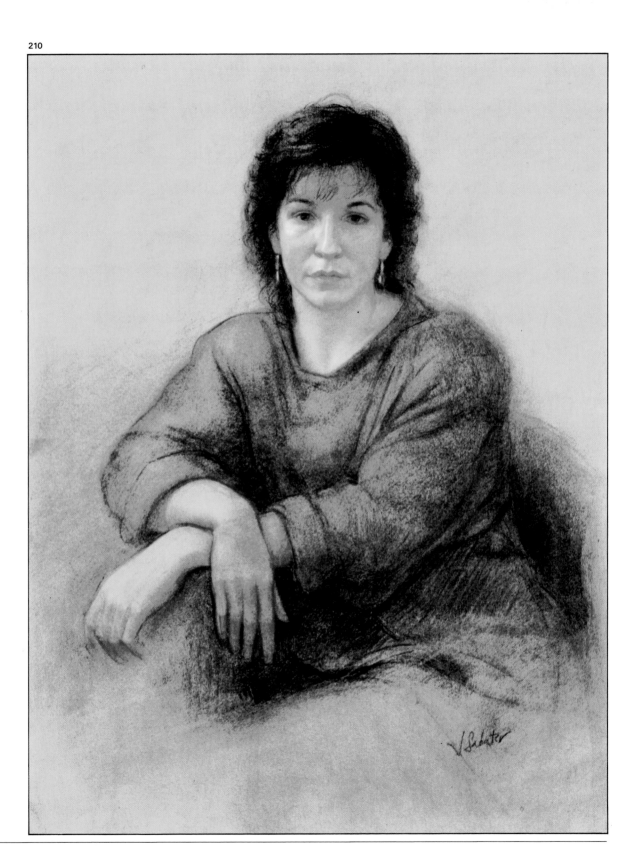

Contents